Published by Adlard Coles Nautical
an imprint of Bloomsbury Publishing Plc
50 Bedford Square, London WC1B 3DP
www.adlardcoles.com

Title of the original French edition:
Yachting! L'esprit voile
© 2012, Éditions Glénat, 37 rue Servan, 38008 Grenoble, France

English translation copyright © Adlard Coles Nautical 2013
First published by Adlard Coles Nautical in 2013

ISBN 978-1-4729-0164-4

A CIP catalogue record for this book is available from the British Library.

This book is produced using paper that is made from wood grown in managed, sustainable forests.
It is natural, renewable and recyclable. The logging and manufacturing processes conform to the
environmental regulations of the country of origin.

Typeset in 10 pt Lintotype Didot by Margaret Brain
Printed and bound in China by C&C Offset Printing Co.

yachting

A VISUAL CELEBRATION OF SAILING PAST AND PRESENT

Olivier Le Carrer

ADLARD COLES NAUTICAL

B L O O M S B U R Y

LONDON · NEW DELHI · NEW YORK · SYDNEY

CONTENTS

Alchemy. Water, sails and wind: the materials may have changed over the centuries, but the magic is still there.

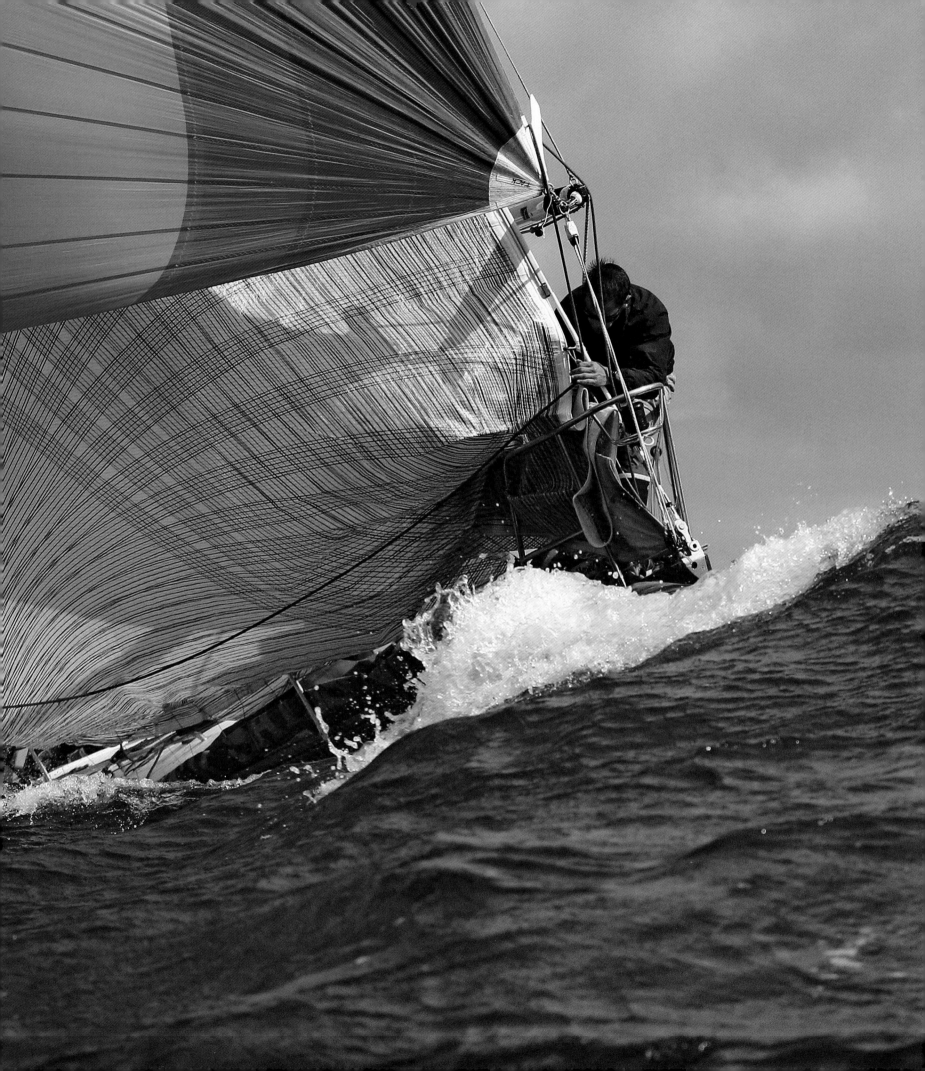

YACHTING?

Is yachting a sport for rich people and royalty? Yes and no. Certainly, the great and influential people of this world have often had a penchant for sailing and have helped write a few pages of its history, from King George V to Prince Harald of Norway. Naturally, you need a bit of money to go sailing – quite a lot of money if you want to make an impact. For all that, the rich and royal only make up an infinitesimal part of yachting's vast galaxy, and it would be wrong to attribute too much significance to them in this sport or to associate importance with the size of yachts and millions spent. The facts point to quite the opposite: the main drive behind the development of yacht clubs from the end of the 19th century onwards was not the proliferation of luxury vessels but rowing. This was a sport practised on small boats or canoes – simple craft usually built by the user himself in his garage at very little cost.

The term 'yacht' does not refer to particularly luxurious craft but to all pleasure boats regardless of size. And yachting means no more than pursuing leisure activities in pleasure boats – at the helm of a dinghy on the river, taking part in regattas, on the open sea in a cruising yacht or pottering from one harbour to another in a motor boat.

Contrary to popular belief, the origins of yachting don't have anything to do with showing off – although today some people do. The sport developed under encouragement from the Royal Navy and through a societal trend towards clean living. It was the wish to improve the seamanship of officers that drove the British Admiralty to foster sailing as a leisure activity from the 18th century onwards (a move soon copied by other nations). This naval connection has had an enduring influence with its etiquette and rather rigid traditions and habits, the whole tinged with a pinch of snobbery.

The 19th-century movement towards clean living transformed unpopular physical activities into modish disciplines within the space of just a few decades. In the pursuit of health and enjoyment, it became fashionable to set off into the natural world for sport and adventure. In this context, it is easy to imagine the immense possibilities of sailing, which provided a means of getting away from the polluted air of the cities and pursuing a healthy activity in full contact with the elements.

It is easy to understand how the word 'yacht' can be misinterpreted. As I have stressed before, all pleasure boats are by definition yachts, and yachting is nothing other than the art of using them. Even if the large sumptuous vessels obviously capture our attention, they only represent a marginal part of a wider, more contrasting universe.

The art of sailing is never completely mastered, feeding as it does on the input of others as well as on your own instinct. This is what makes yachting so difficult and at the same time so appealing – it invites humility and provides a permanent challenge. It is also a way of life that links its various participants through cultural references, shared interests and habits such as looking at the sky or planning a trip. Yachting as a way of life is sufficiently universal for the crew of a 6 m yacht and that of a maxi yacht to be able to recognise and understand one another.

Preconceived idea number one: yachting is a princely lifestyle. Quite the opposite! It is precisely because the pioneers of yachting spent most days in their princely abodes that they wanted a change of air, choosing a sport in which they would come up against hostile elements in conditions that were a little spartan. All things considered, it was like camping on water. Accommodation may have been damp and cramped, but there was the wind, the sea and a temperamental sky giving a whiff of adventure to the proceedings, with an element of uncertainty thrown in.

The size of vessel does not alter anything very much; you always have the break with terrestrial habits (notably those associated with comfort and fixed hours) and the pleasure of mastering all kinds of techniques to make everything go as smoothly as possible (or keep bad things at bay) in an environment where nothing is ever certain.

Mundane achievements take on a victorious quality worthy of celebration: a skilful manoeuvre in a crowded harbour, a successful voyage through fog and strong currents, eking out the precious diesel fuel or producing a simple hot meal of sausages and mashed potatoes, which takes on the allure of a royal feast because you managed to cook it at an angle, with the boat running as she should and the sea belonging to you. This response to challenge often takes a turn that is scarcely comprehensible to the landlubber: take the sailors who abandon all sense of reason when they become infatuated with splendid but barely functional boats. All that matters is the beauty of the boat's motion…

THE ESSENCE
OF YACHTING
A BEAUTIFUL DISCOMFORT

Tightrope walking. Grace meets brute force during a manoeuvre on the schooner *Eleonora.*

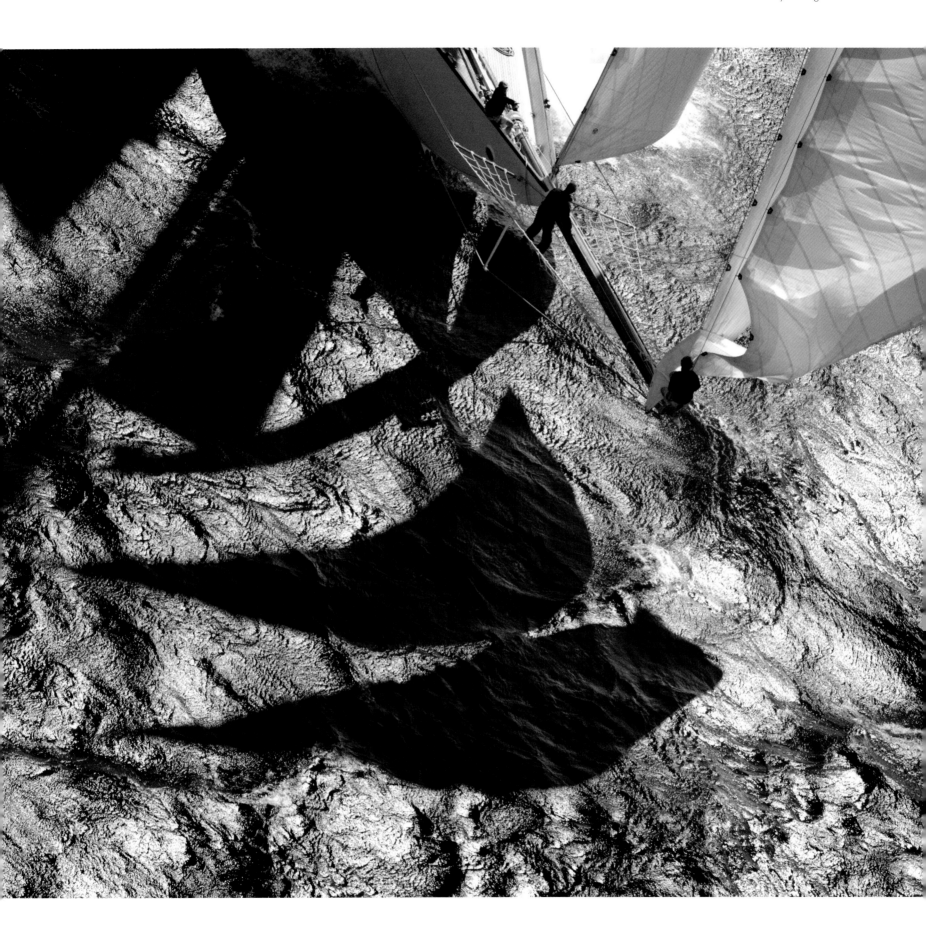

Savage beauty
BOATS THAT ARE SO BEAUTIFUL AND SO DEMANDING

'Who goes to sea for pleasure alone would go to hell to pass the time,' seamen used to say, incredulous at people choosing to spend their holidays where they would only venture grudgingly to earn their daily crust. They were, however, forgetting one important detail: those who love sailing are not exposed to the elements every single day. They can set off when they want, for the destination of their choice and only if the weather conditions suit them (returning if not). They can take the best from the seas that are capable of the worst. They are the only masters on board and do not have to share their vessel with tons of icy fish. They enjoy the special privilege of being able to choose their constraints.

In this subtle association between hedonistic aspiration and stoic virtue, difficulties are no bar in the pursuit of the beautiful and interesting. The link between challenge and beauty is apparent in the century-old, still majestic William Fife designs, in the lines of *Pen Duick*, *Moonbeam III* or *Tuiga*, with delicate hulls that seem to disappear under their immense sails. A magical spectacle for onlookers and guaranteed prestige for the demi-gods disembarking from such vessels.

Sailing these beautiful, demanding boats is a much less smooth and harmonious exercise than it appears. Because of the narrowness of their decks, their angle of heel and the absence of any railing one always runs the risk of falling into the water. However, no pain, no gain; it is precisely this inconvenience that makes these yachts so elegant.

Tradition. The pleasure of rediscovering the movements of yesteryear on superb and very demanding yachts.

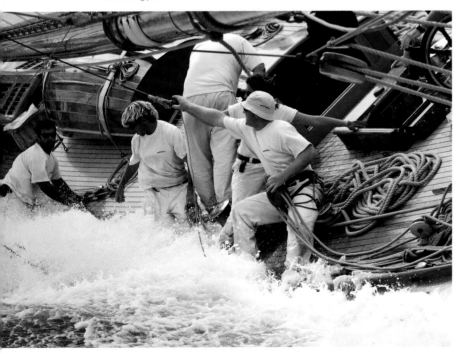

Gusts. The beautiful schooner *Eleonora* meets with a squall in Cannes harbour at the Cannes Royal Regatta.

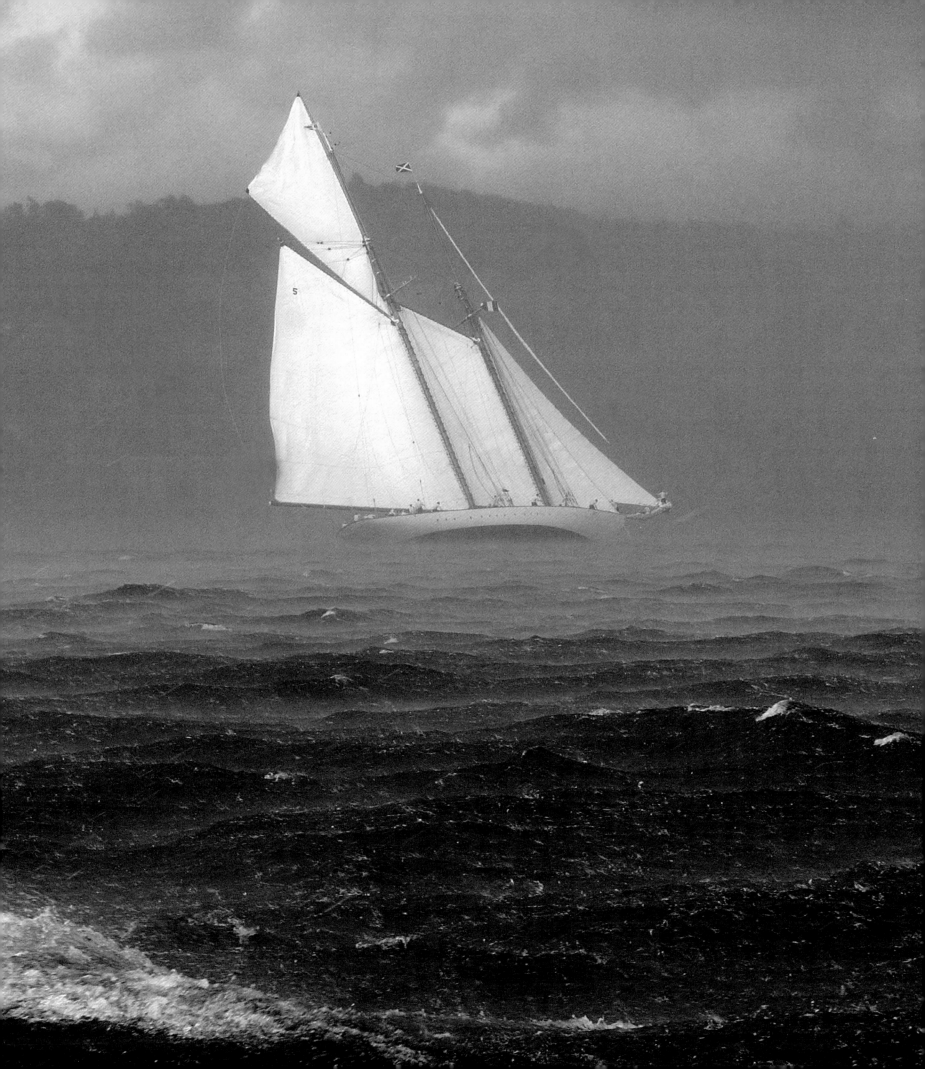

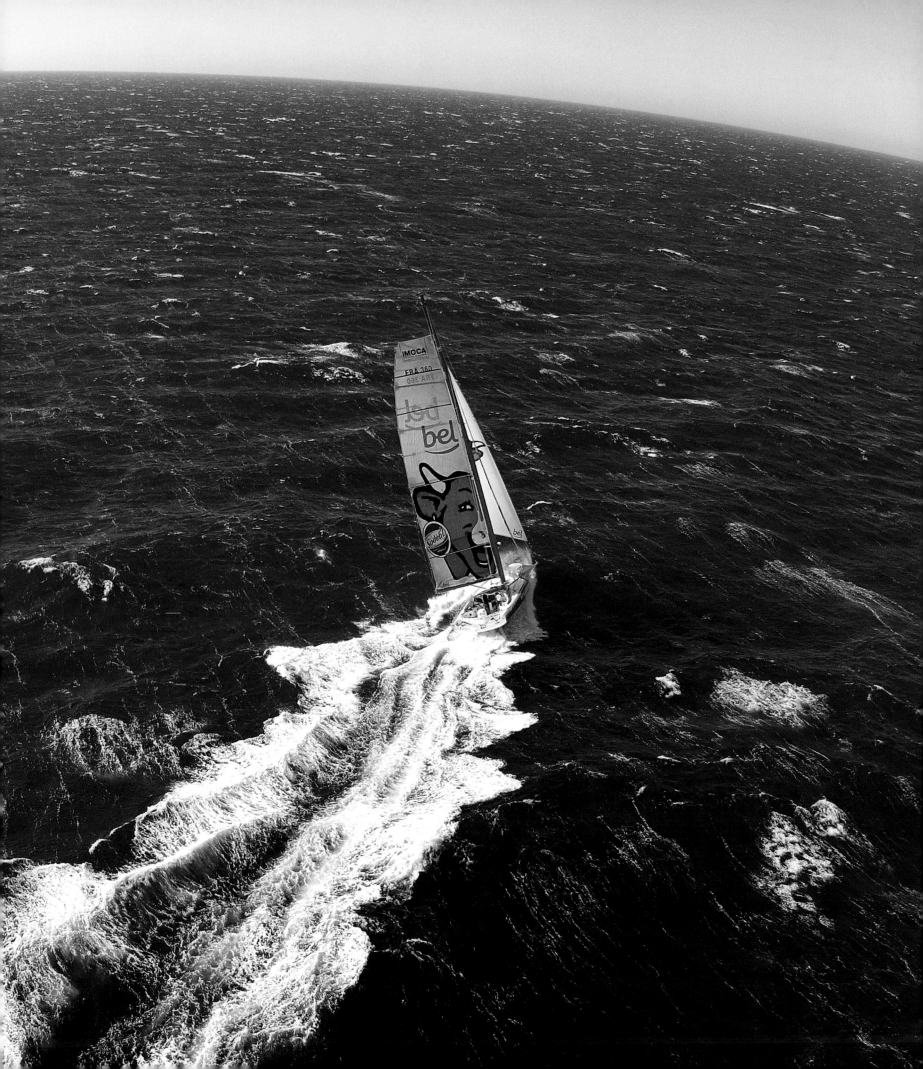

What is a yacht?
WHEN SIZE REALLY DOESN'T MATTER

There are many different types of yachts and different ways of sailing them. Take King George V and his legendary *Britannia*. Both are emblematic of yachting, in terms of his style, her beauty and his indestructible passion for her, with her majestic shape and 900 sq m of sail area on a length of 31 m. Are we then to conclude that the size of vessel and blue blood are somehow linked to yachting? No. These things may occasionally help but are by no means a deciding factor. Nowadays, the name that best illustrates yachting is *Runa IV*, a nearly 100-year-old Danish yawl. She only measures about a dozen metres and is quite uncomfortable and impractical to sail but nevertheless has a rare elegance. Yves Carcelle, the president of Louis Vuitton, devoted two years of work (and a tidy sum of money) to renovate this boat. Is all this simply a question of cash and prestige? Not really. Hundreds of other boats, owned by unknown people with often modest budgets, give just as much enjoyment to their owners, crews and shoreside observers.

Particularly in southern Europe, the word 'yacht' is often used to denote any boat that is large and expensive.

British culture, on the other hand, considers all sailing boats yachts. International terminology continues to define a yacht as any sailing boat that takes part in regattas. This even includes Optimists, a class of walnut sailing dinghies devised for children learning to sail. Their length is a mere 2.30 m, with no cabin or notable woodwork, but they are nevertheless yachts. By contrast, a traditional working boat, no matter how attractive, cannot expect to classify as a yacht.

The boats that are most often called 'yachts' – I am thinking here of the great motor boats you often see in Mediterranean ports – are, paradoxically, poles apart from actual yachting. Why? Because they shamelessly ignore the sport's most basic tenets: a good dose of culture, some complicated constraints and a touch of discomfort.

To be a yachtsman is not about the boat but about culture and attitude. It is not necessary to have timber yards and a retro line to gain your stripes; all materials and styles are eligible, provided you make good use of them.

Diversity. Common ground between old and new, large and small: the pleasure of sailing.

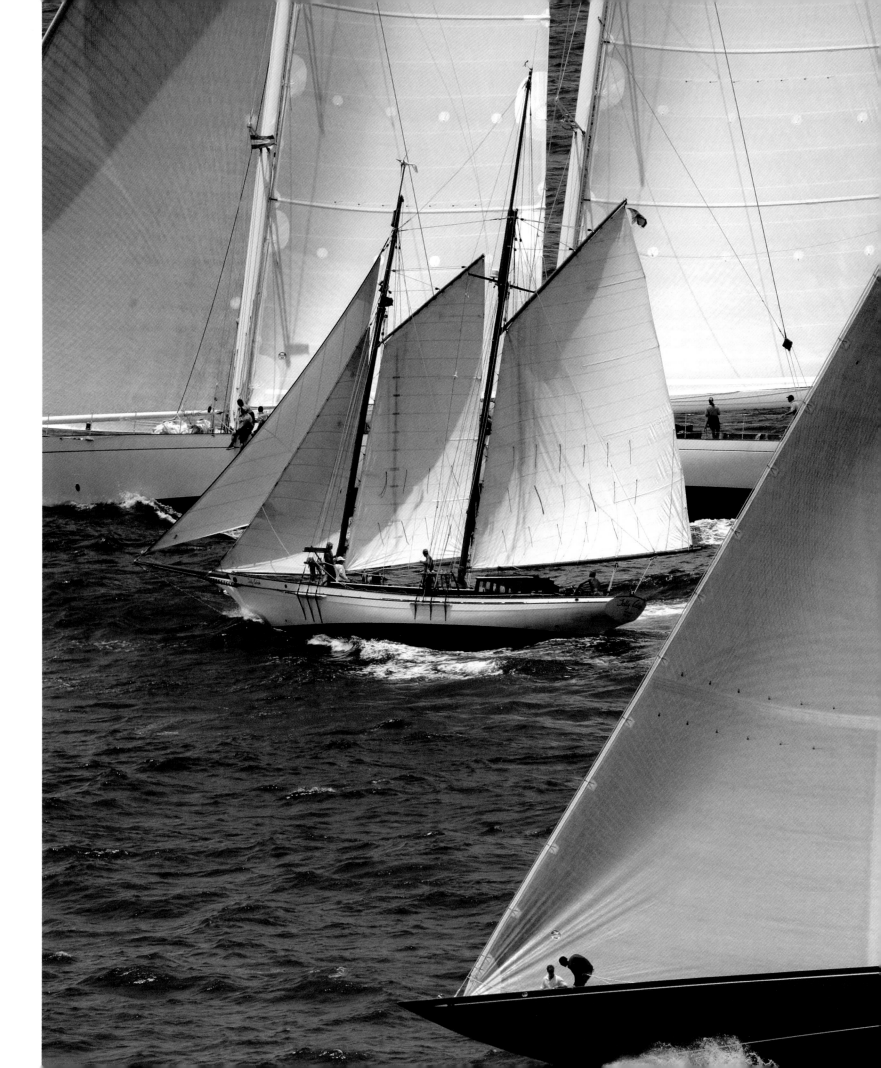

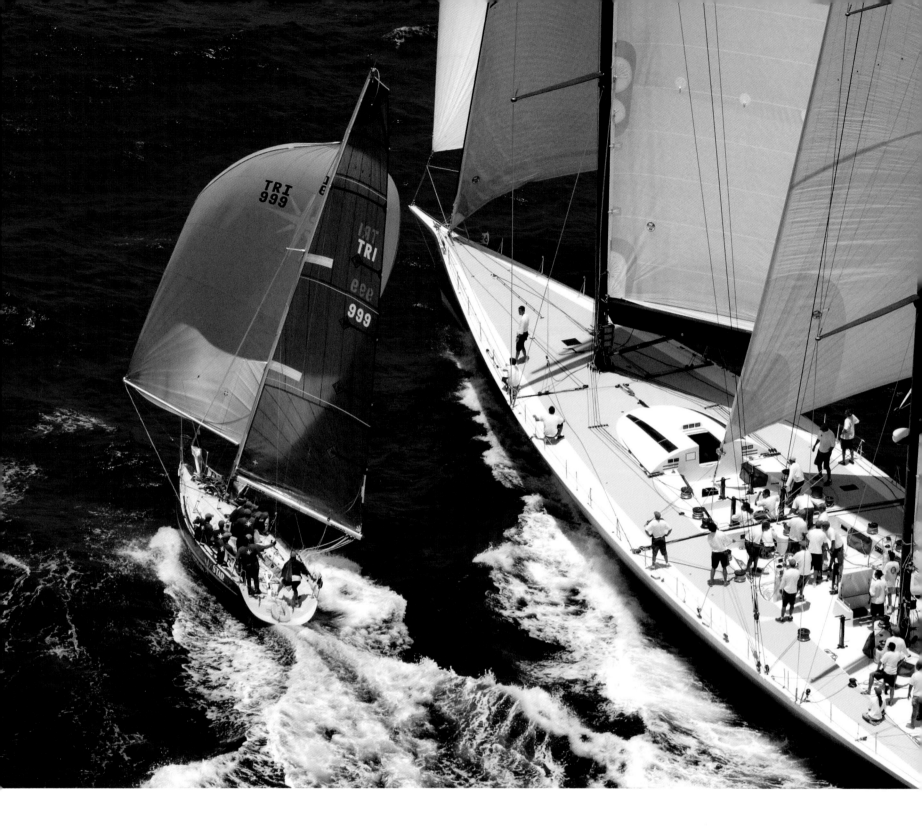

Contrast. Side by side, an 'ordinary' racing yacht and *Mari Cha IV*, a giant of 42 m in length.

"" *To be a yachtsman is not about the boat but about culture and attitude.* ""

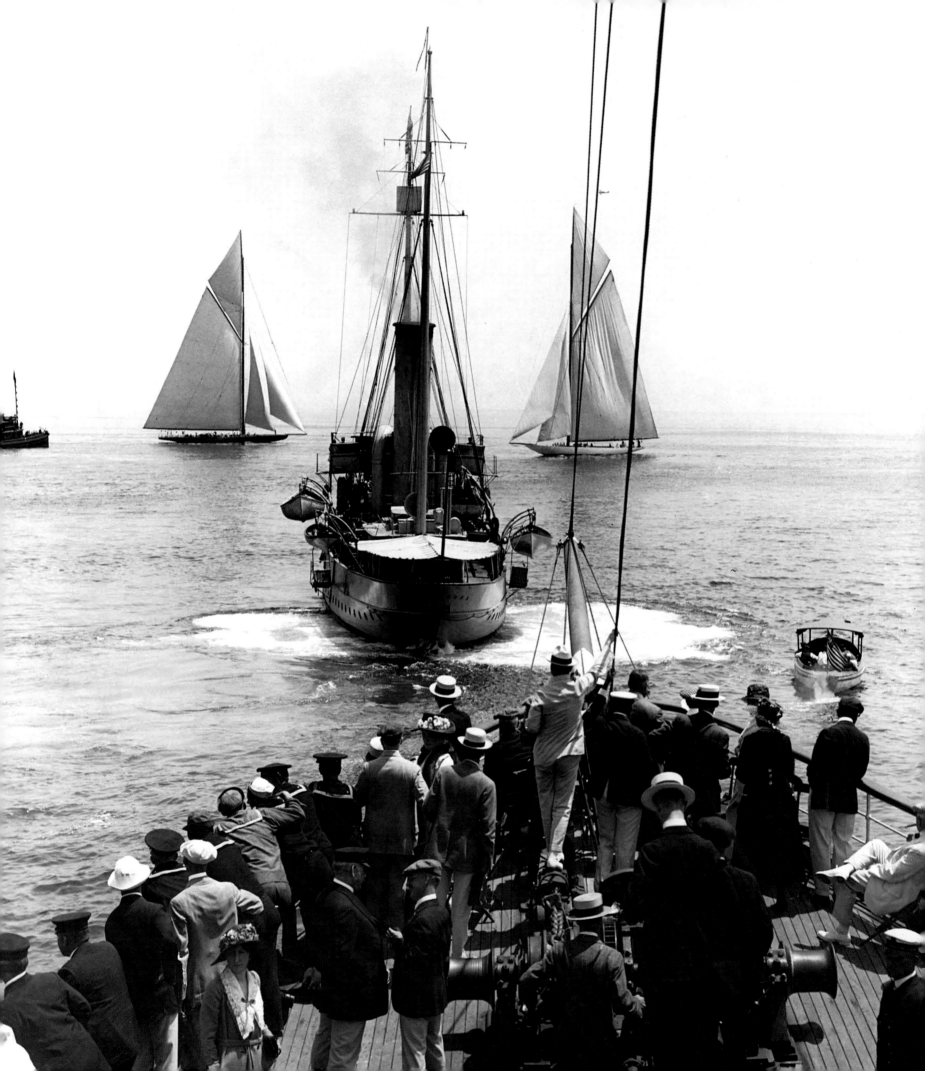

The values of yachting
THE SCHOOL OF FAIR PLAY
(IN PRINCIPLE AT LEAST)

'All sports involve some risks. But is it not saner and nobler to rediscover the pleasure of slowness, of effort and patience, far away from the life that oppresses us, shackled by timetables and by this obsession with speed which we confuse with happiness, incapable as we are of distinguishing joy from movement?'

This enthusiastic plea by Marthe Oulié, a young archaeologist passionate about sailing, at the beginning of her 1925 book *Quand j'étais matelot* (*When I was a sailor*) sums up the essentials. To begin with, the cardinal virtues of effort and patience – still applicable today. One might add humility, because even with the best equipment in the world and the most in-depth knowledge we are still small before the force of the elements. And one could also add perseverance, knowing when to hang on in difficult conditions.

These integral values of seafaring are often eclipsed by another: fair play. Regattas should represent a world of cordial challenges, where competitors provide for the latecomer and where respect for your adversary borders on religion. This rather nice picture owes a lot to the aristocratic origins of the sport. The tradition of fair play has persisted for a long time, with racers withdrawing from the regatta when they have inadvertently made a mistake. This is a consummately elegant

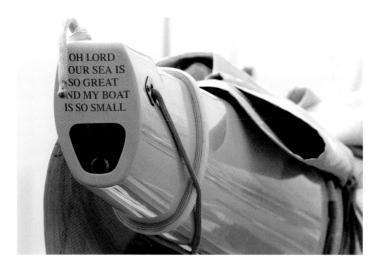

Humility. This short prayer of Breton fishermen has been popular all over the world. It has been adopted by the US Navy as well as this racing yacht.

gesture, which makes it superfluous for a jury to convene afterwards to evaluate the nature of the transgression, and to debate the need for sanctions. Unfortunately, even if there is still sporting behaviour here and there, notably the ease with which contestants come to each other's aid or lend each other materials when someone suffers damage, fair play, generally speaking, is no longer seen.

Crews are more ready than ever to display the protest flag (a signal that one wishes to bring a complaint against another boat) and take advantage, at least at the higher levels, of legal advisers who will do their utmost to get them out of sanctions.

Suspense. The duel between the Irish boat *Shamrock IV* and the American *Resolute* will go down in history as one of the great sporting confrontations of the America's Cup. The Americans won 3:2.

However, aggression, bad manners and the pursuit of victory at all costs are nothing new. In 1851 John Cox Stephens and his friends from the New York Yacht Club only paid part of the agreed sum ($30,000 at the time) to the builder of the schooner *America*, on the grounds that one day out on the water another racing yacht had reached a greater speed than her. When they decided to compete in England and won, the victors assured their challengers that they would 'receive a warm welcome in New York and could compete in an unimpeachable spirit of fair play' in a race henceforth known by the name of the winning boat as America's Cup. When the British yachtsman James Lloyd Ashbury took up this challenge in 1870 with his schooner *Cambria*, he was expecting a duel with the defending champion, but was forced to face a fleet of seventeen US yachts instead. The history of the America's Cup, which is nevertheless a supreme example of the spirit of yachting, is marred a little by secret goings-on, spying, attempts to bend the rules and legal conflict (see also pages 137–8).

Without being better than other sports when it comes to fair play, yachting must at least stick to the values listed above, a direct consequence of its exposure to the forces of nature. Through necessity, if not through taste, real sailors have every chance to learn to be more resilient in situations of adversity than the average landlubber. At least they should not complain about their lot, for it is useless to be overwhelmed by the elements or failing equipment – one simply has to get on with it. Having to share the restricted space of a harbour or anchor alongside other boats makes them inevitably more aware of others. Then there is the comradeship of the sea, with sailors always willing to help one another.

Constantly exposed to the elements, in surroundings where they salute natural beauty on a daily basis, yachtsmen have powerful reasons for wishing to protect the environment and most of them have now become zealous defenders of nature. Sailors have not always been conscious of the damage they might be causing, but nowadays it is no longer acceptable to throw superfluous material overboard in the middle of the Atlantic to lighten one's boat as Vendée Globe winner Titouan Lamazou did in 1990.

And one more thing: it is undoubtedly because it is not easy for several adults to live together peacefully in a floating home scarcely larger than a prison cell that there is much emphasis on courtesy and manners. Let's hope this lasts!

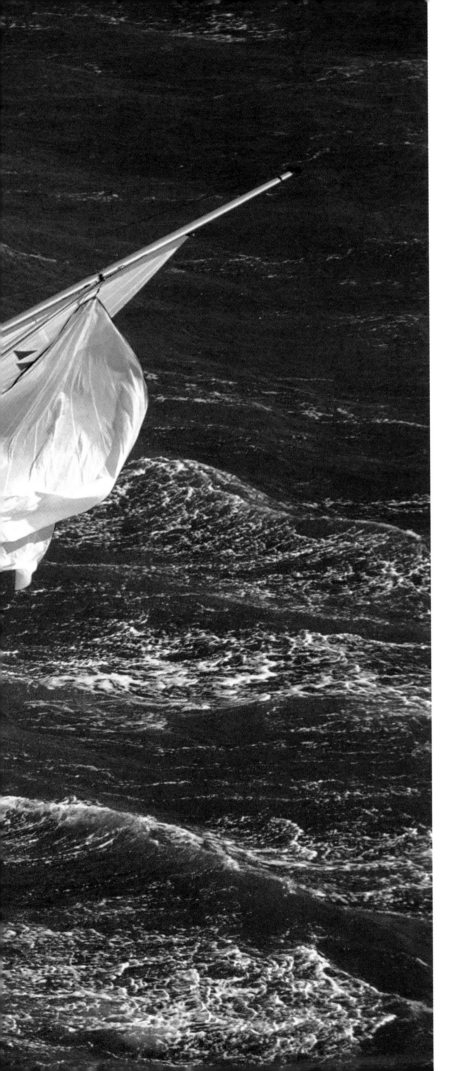

Technique
THE FAILED MANOEUVRE

S cientists like to speak of chaos theory, of how a small change in a seemingly stable environment can lead to total confusion. A good example is how a small downward shift in temperature can cause liquids to turn into solids. Sailors are well acquainted with this. It is that moment when the sky seems to be falling on top of you when all was well only a moment before. The yacht that was proudly parading ahead of the fleet finds herself suddenly in a pitiful position after an acrobatic gybe, sails trailing in the water, overtaken on all sides by the other competitors and, worse still, in danger of striking a nearby rock. In just a few split seconds all kinds of worry flash by – being mocked at the yacht club bar, repair bills, not to mention real danger to the boat or crew – while the skipper bemoans the unfair balance between clumsiness and disaster.

Landlubbers may be surprised by how small events can have such major consequences. From a certain distance, a

Spinnaker broach. A brief lapse of concentration can lead even a seasoned crew into instant trouble.

boat's manoeuvres may seem self-assured, any change of course is carried out smoothly until the craft disappears over the horizon or comes to glide gently along the pontoon. If one gets close enough, though – or, better still, if one boards the vessel – one realises that this harmony is very precariously balanced. An unfortunate movement, a moment's inattention, an external interference or some minor damage is enough to pass from majesty to chaos. 'To make a successful manoeuvre is nothing other than to avoid disaster,' as the regulars like to say with a little modesty and much realism. There is some truth in this, in that the factors are very varied and the potential pitfalls numerous. Imagine parking the car with one person at the wheel, another manning the reverse gear, a third controlling forward acceleration while also being responsible for operating the clutch. The car would, of course, have no brakes and drive on a rippled road, which means it would skid from left to right and vice versa.

Tackling a difficult manoeuvre calls for several sets of reflexes simultaneously: those of an engineer (which turning radius to choose, when to straighten the helm), a manic accountant (nothing left to chance), a coach (to organise everyone's effort properly), a peasant (to be at one with the elements) and an artist (for the flair that comes only through instinct).

The sword of Damocles is thus permanently raised above all sailors; it is at once their cross to bear and their joy. The quest for the perfect manoeuvre (which can never be taken for granted) is one of the most stimulating incentives to go out there. If the sinister noise of the hull scraping against the harbour wall or of torn sail flapping haunts the skipper's thoughts, it is hardly of any consequence compared with the immense satisfaction derived from successfully gybing a spinnaker (or almost – one has to hold back some ambition for later!) and the pleasure felt at onlookers' quiet approval after you've skilfully berthed your boat.

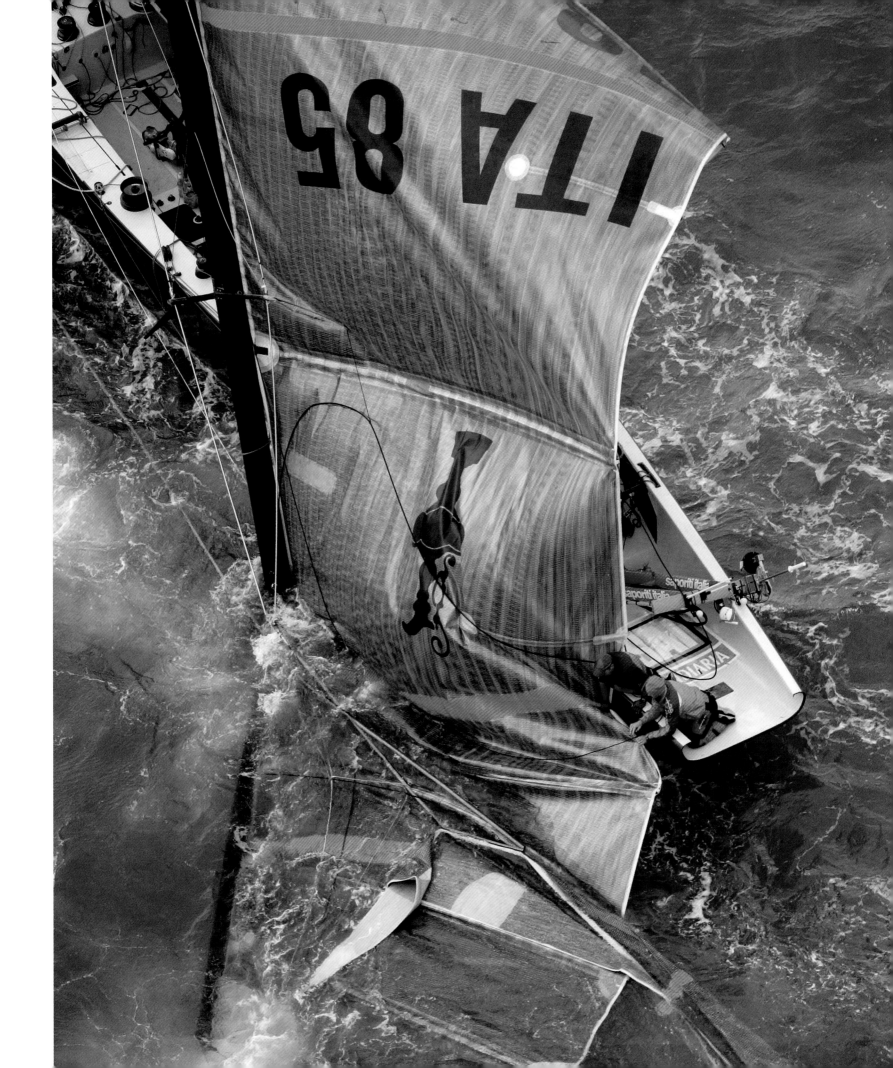

Bunks
THE UNBEARABLE LIGHTNESS OF SLEEP

There are many reasons why it is impossible to sleep well on a boat. There is always noise (the wind blowing through the rigging, the creaking of ropes, an object bumping on deck, the lapping of the water against the hull, and so on) as well as unsettling movement, uncertain holding and changing weather. All these invite vigilance and mean you are only ever half asleep.

The cabin of a small boat is also hardly the ideal haven of peace and rest. It is not only cramped but also often badly ventilated. When you have the good fortune of a watertight deck – that is, one without the irritating trickle of water falling on the off-watch crew curled up in their bunks – you are usually too hot. And there will be no porthole to improve the situation, or at least only one positioned in such a way that the rain and the spray would enter the cabin, leading once more to the previous scenario.

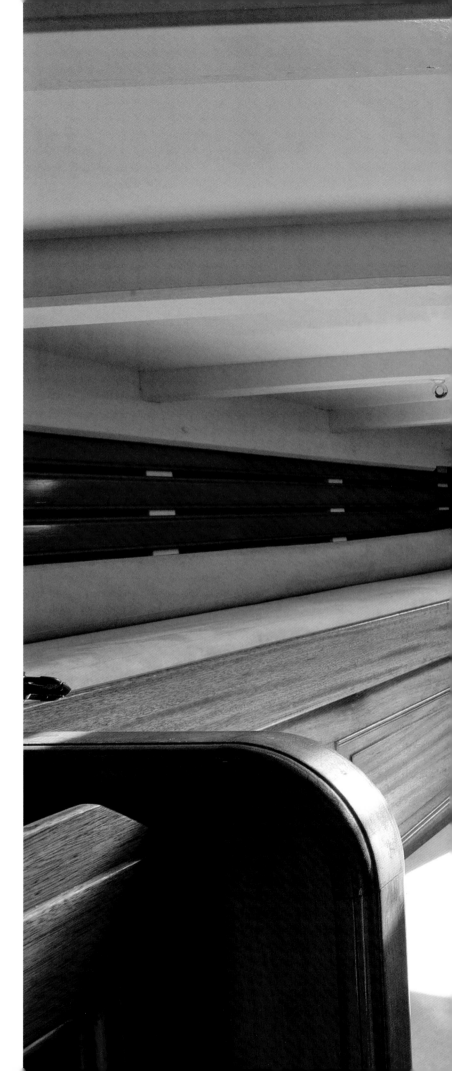

Sobriety. The cabin of a classic yacht, with its narrow but functional bunks.

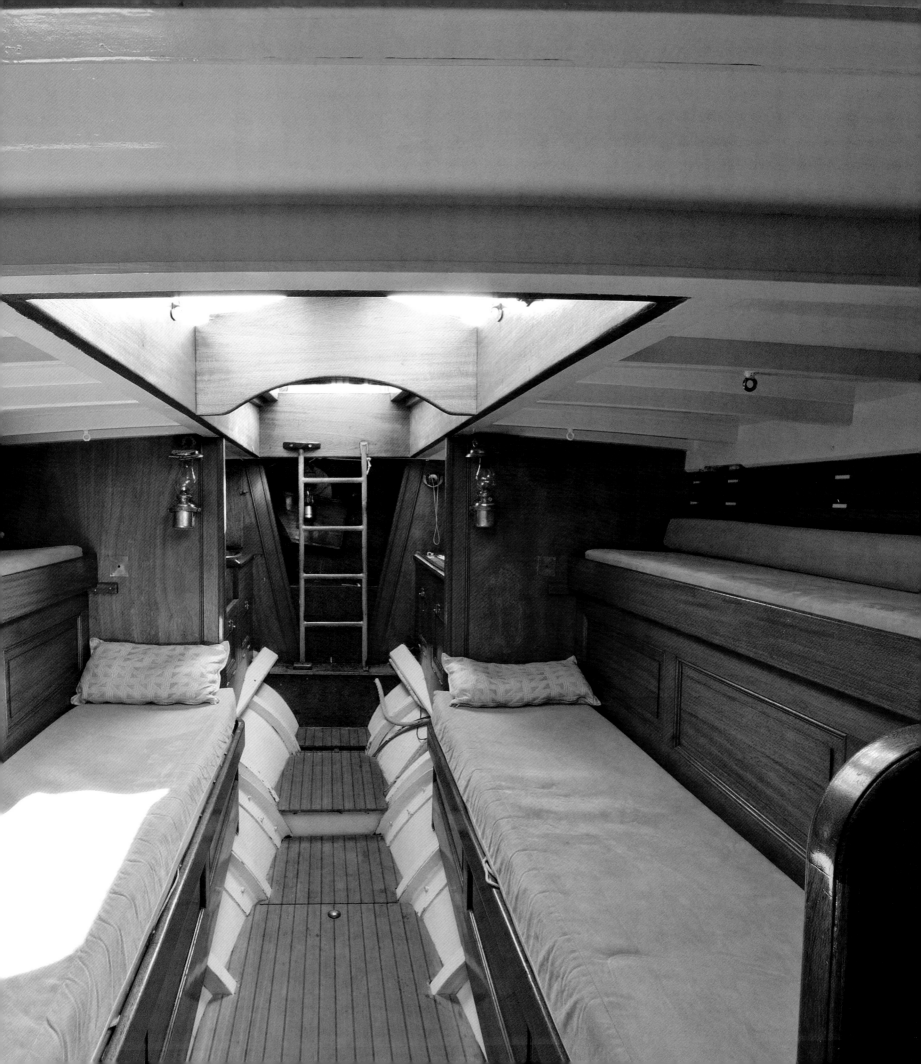

> 66 *Happy are the sailors that are perfectly slim and not too tall, because they will find themselves best off in the kingdom of boats.* 99

It may also be worth mentioning the smells, which vary according to the type, age and material of the boat (and even her crew) but which are rarely agreeable. These range from dankness as you get in summer houses that have been closed for years, to fuel and mildew, not forgetting the smell of brand-new boats with their aggressive scent of freshly polymerised polyester.

As if that were not enough, there are the 'beds' themselves. Whether one calls them bunks or berths makes little difference. The first grievance that can be directed at the bunks is their size. Happy are the sailors that are perfectly slim and not too tall, because they will find themselves best off in the kingdom of boats. It is not unusual to find berths less than 1.80 m long and their overall shape is often illogical. For example, they are generously wide at the head but narrow at the shoulders and end in a tapered point, forgetting that the human body includes two feet – unless there has been an accident. Recent models are no better, their interiors so well 'designed' that you have to sleep in the foetal position or in a double bunk that is a kind of sarcophagus, with an average height of 40 cm.

One should be glad to have a bunk to oneself, however. In a number of racing yachts this is an impossibility, and crew members have to hot-bunk (sharing bunks according to the watch schedule), with the inevitable misunderstandings that may arise on a personal level. The most marvellous thing about all this is that sometimes one is even happy with this and manages to get some sleep! It just shows that yachting is indeed a fascinating activity.

Racing trends. To enable crews to rest in adverse conditions, the bunks can incline by means of pulleys.

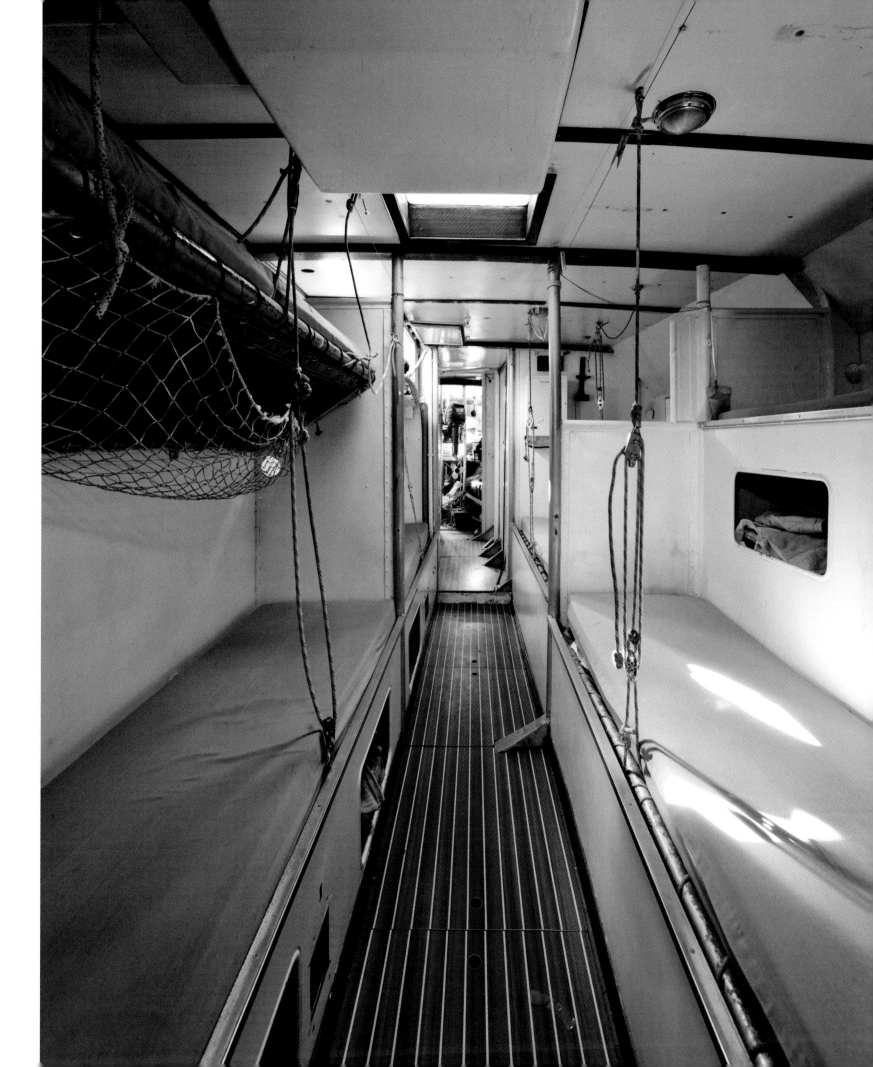

Believe them or not, they can't be ignored. Even if yachting myths are sometimes questioned, they nevertheless form the basis of a common culture with highly coveted brands, legendary places, objects, people and traditions. Inevitably, not all have the same cachet. Some prestigious names have lost the lustre of their forebears; they are practically obsolete or are changing dramatically. If some of these nonetheless appear in the following pages, it is because of their evocative power, their persistence in the collective imagination (that of non-sailors as well), regardless of their current status.

Some petty squabbling is found in this context. You will always find someone who will say that Doug Peterson is a more gifted yacht designer than Olin Stephens, that Bruce Farr has a more impressive list of achievements or that Dick Carter and Jean-Marie Finot have brought more new ideas to the table. That's not necessarily wrong, but for a variety of reasons it is Stephens' name that is engraved in huge letters in the pantheon of yacht design. In the same way, we may not enjoy the same tipple as our predecessors, but the reference to traditional sailors' drinks is constant and informs our understanding of yachting. Sailors are defined in relation to these myths.

MYTHS
THE LEGENDS OF THE SEA

Winches. Power at your fingertips, thanks to these little wonders that have conquered all types of yacht.

Yacht clubs
WHERE EVERYTHING BEGINS

It is impossible to understand the essence of yachting without considering its social dimension. Yacht clubs will organise regattas and other events, but, above all, they enable like-minded people to come together and share their passion. The first to be founded were the Water Club of Cork in 1720 (now the Royal Cork Yacht Club) and the Cumberland Fleet (still an alternative name for the Royal Thames Yacht Club) in 1775. Undoubtedly the most important development in the history of yachting, however, took place at the Thatched House pub in St James's, London, on 1 June 1815, when 42 gentlemen decided to create the Yacht Club, the first nautical association to bear this name. In 1820 this became The Royal Yacht Club, thanks to three members of the royal family joining (among them the king himself), and later still the Royal Yacht Squadron. This high-class institution would be a major force in organising international competitions from its base at Cowes on the Isle of Wight.

The development of these clubs internationally was slow to begin with. The first club outside the British Isles was the Gibraltar Yacht Club, founded by British officers based on the Rock in 1829, a long way away from London but in a British colony nevertheless. Only in 1830 did the first non-British club appear: the Svenska Segel Sällskapet, since 1878 known as Kungliga Svenska Segel Sällskapet or Royal Swedish Yacht Club. Thanks to this institution, regattas developed in Scandinavia and other clubs sprang up rapidly,

Burgee. The small triangular flag that bears a club's colours.

notably in Denmark and Norway. In France the pioneering Société des Régates du Havre was formed in 1838 with the support of a luxury hotel which hoped to attract the Parisian elite by promoting yachting.

In the same year, the Royal Hobart Regatta Association in Tasmania was the first yacht club to be established in the southern hemisphere, followed in 1853 by the Port Phillip Yacht Club, now known as the Royal Yacht Club of Victoria. The first club to organise regattas in Asia was the Victoria Regatta Club in Hong Kong in 1849. As ever, a keen British influence was felt.

In North America, the first yacht club was not in New York

The Royal Yacht Squadron. Located at Cowes on the Isle of Wight, this is one of the world's most high-class clubs.

but in more northerly waters. In 1837 Canadian yachtsmen founded the Halifax Yacht Club, now known as the Royal Nova Scotia Yacht Squadron. In 1839, the Detroit Boat Club on the banks of Lake St Clair had the honour of becoming the first nautical society in the United States, even though it was mainly a rowing club at this stage and only later added sailing to its activities. The prestigious New York Yacht Club was founded in 1844 by nine prominent sportsmen, including John Cox Stevens who became its first commodore.

And nowadays? Well, everything has changed, yet it still remains the same. Today's yacht clubs vary widely, as does their membership. You may find opulent club houses, three-figure joining fees and hand-picked members as well as clubs open to all, with quayside shacks serving as club houses. A lot of them focus almost exclusively on sport and competition, and membership is not as obligatory as it used to be. However, one always gets excited in their convivial atmosphere, discussing boats over a drink or two with people whose only fault is to have a yacht faster than yours and implementing all manner of projects.

The only major sailing magazine that is published fortnightly (ever since its launch in 1904), the German *Yacht*, seems to be faring well. It is the most widely read boating magazine in Europe, despite no fewer than 28 competitors in its own country alone. The importance it places on both its home waters and sunny cruise destinations – to which German yachtsmen are very partial – is no doubt a factor in its success. *Yacht* is one of the oldest boating titles in the world still going, along with the British monthly magazine *Yachting World*, which was launched slightly earlier, in 1894. *Yachting World* focuses on the major international races and the most up-to-date prestigious boats, with an impressive listing of second-hand yachts for sale.

The European pioneer, however, was founded in Paris in 1878. *Le Yacht, Journal de la Marine*, published each Saturday, delivered a dozen or so pages that were austere but packed with enough information to keep impatient readers' enthusiasm going. This unusual publication would last until 1968 (no fewer than 90 years) but could not survive among fierce competition after that. This was mostly the fault of Pierre Lavat, a former student at the École Navale, who in launching the magazine *Bateaux* in 1958 criticised *Le Yacht* for being a regimented journal of the old school.

The final tendency for this sort of publication? In a word, specialisation. Everywhere in the world it is the same story. The titles multiply, often capitalising on a specific niche in the increasingly diversifying market (a region, type of boat or style of sailing). Consider the United States, home to no fewer than 58 boating magazines. There is, however, one constant thread: a shared passion for sailing.

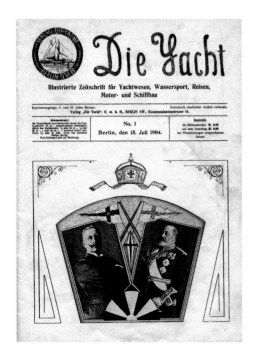

J class yachts

DELUSIONS OF GRANDEUR

J. This letter alone appears on enormous yachts that slice through the waves. To mention it is enough to evoke unforgettable yachts such as *Britannia* or *Reliance* (mistakenly, since neither was actually a J Class). There is always a misunderstanding that hovers around these boats – people tend to groups all boats that have taken part in the America's Cup as J Class. The story of the J Class yachts, though brief, is exciting. The heyday of these great sloops only lasted from 1930 to 1937, not an enormous length of time, but long enough to capture the imagination of yachtsmen for 60 years. Ten boats were built during this time. Of these, only three are still sailing, all of them British: *Shamrock V*, *Endeavour* and *Velsheda*. Some other old boats, with different tonnages, have undergone modifications to make them J Class, such as the *Astra*, *Cambria* and *Candida*, all built in the 1920s. Replicas have also been built recently, such as *Hanuman*, a replica of the *Endeavour II*, and the highly impressive *Ranger*, making it possible to replay the

Renaissance. A replica of the impressive boat that won the 1937 America's Cup, the new *Ranger* continues to inspire those passionate about sailing.

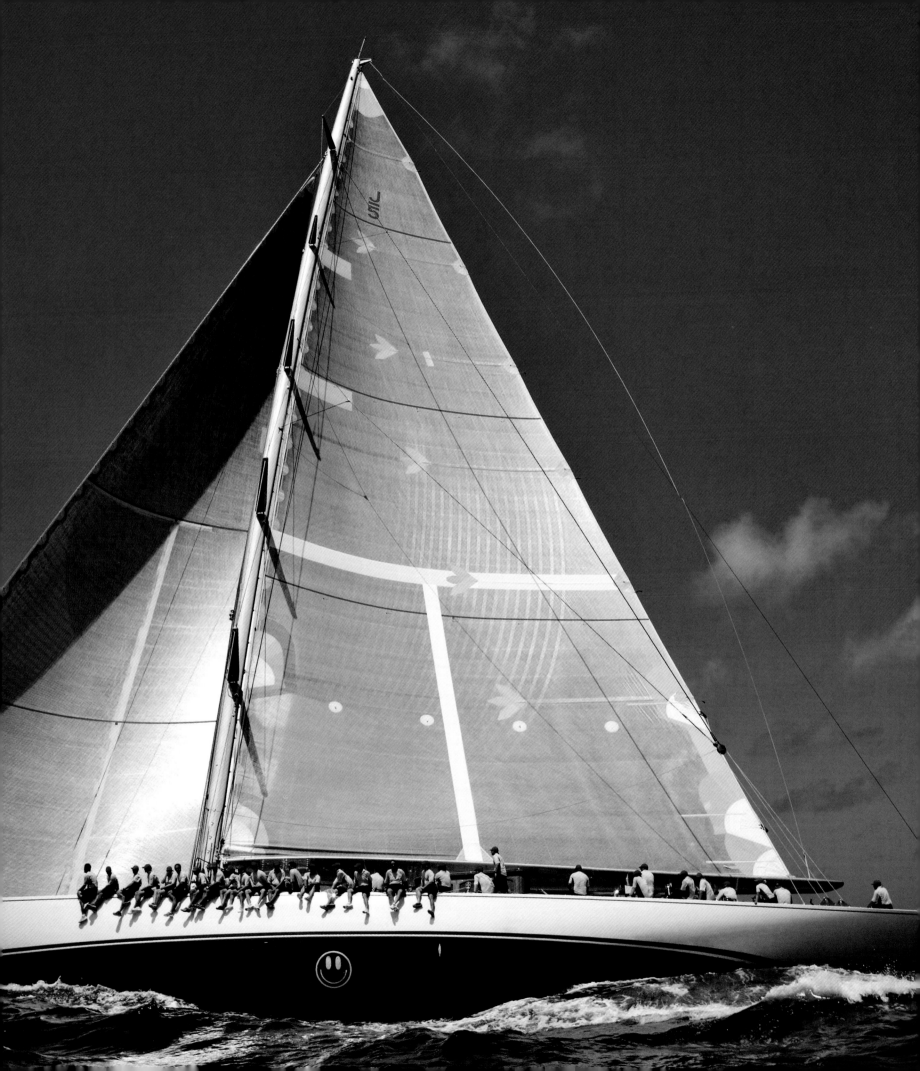

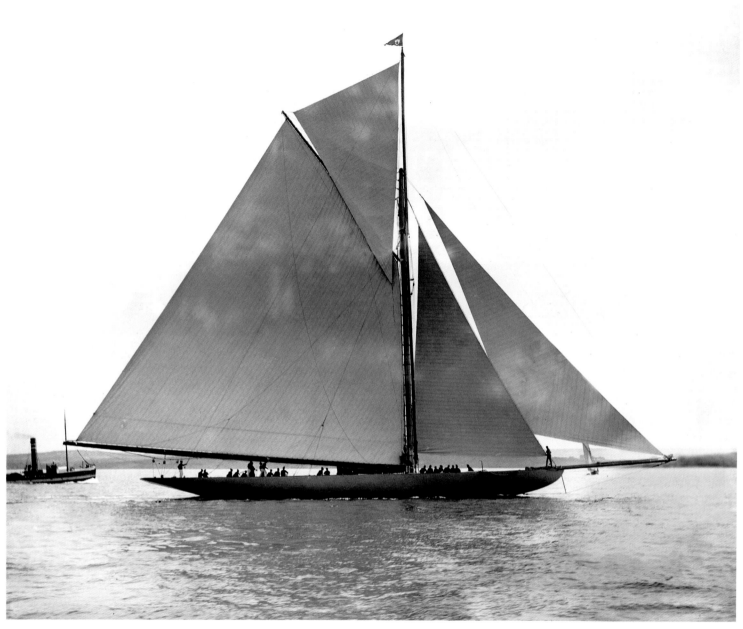

The first giants. The measurements of *Shamrock I* in 1899 anticipated those of the future J Class yachts built from 1928 onwards.

match of 1937, in which the American defender, *Ranger*, won 4:0 against its British challenger at Newport, Rhode Island. Thanks are due to the sponsors who provide the means for us to experience this spectacle from the past.

The misunderstanding of what constitutes a J Class yacht is also a technical one. The truly giant boats belonged to previous generations. In 1903 the America's Cup defender *Reliance* boasted a length in excess of 60 m and a sail area of 1,500 sq m. Compare this with the J Class *Ranger* 34 years later – she 'only' measured 41 m with a sail area of less than 700 sq m. This may well make us smile these days, but the promoters of the new Universal Rule for sail racing required more 'reasonable' boats, eliminating the interminable booms that increased sail areas and avoiding the need for extensive crews (there were 64 men on board *Reliance*!). The illustrious American naval architect Nathanael Herreshoff, a famous

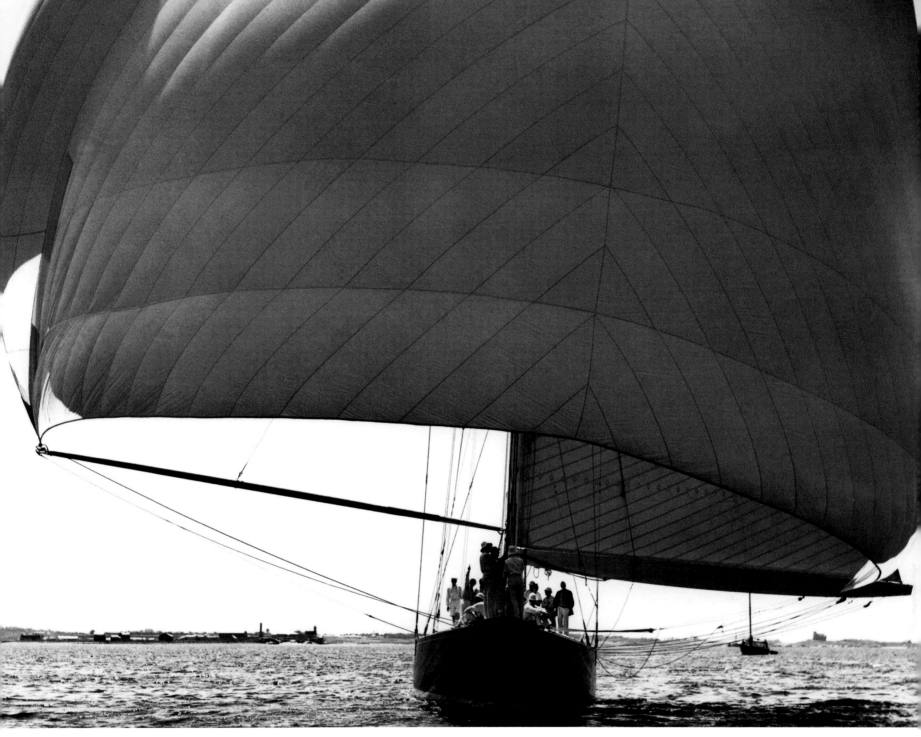

Mountains of sails. Going downwind, *Endeavour* could carry more than 2,000 sq m of sail.

promoter of the Universal Rule, could count on an additional argument: Limiting the waterline length (to 75–87 ft) enabled contestants to race in real time, avoiding tedious calculations of handicaps.

The new J Class yachts were still too expensive for many countries struggling to come out of the 1929 depression.

The futuristic *Ranger*, owned by the great American railroad executive Harold Stirling Vanderbilt, only sailed for a year, despite winning 35 out of 37 races. She was scrapped in 1941 as part of the war effort.

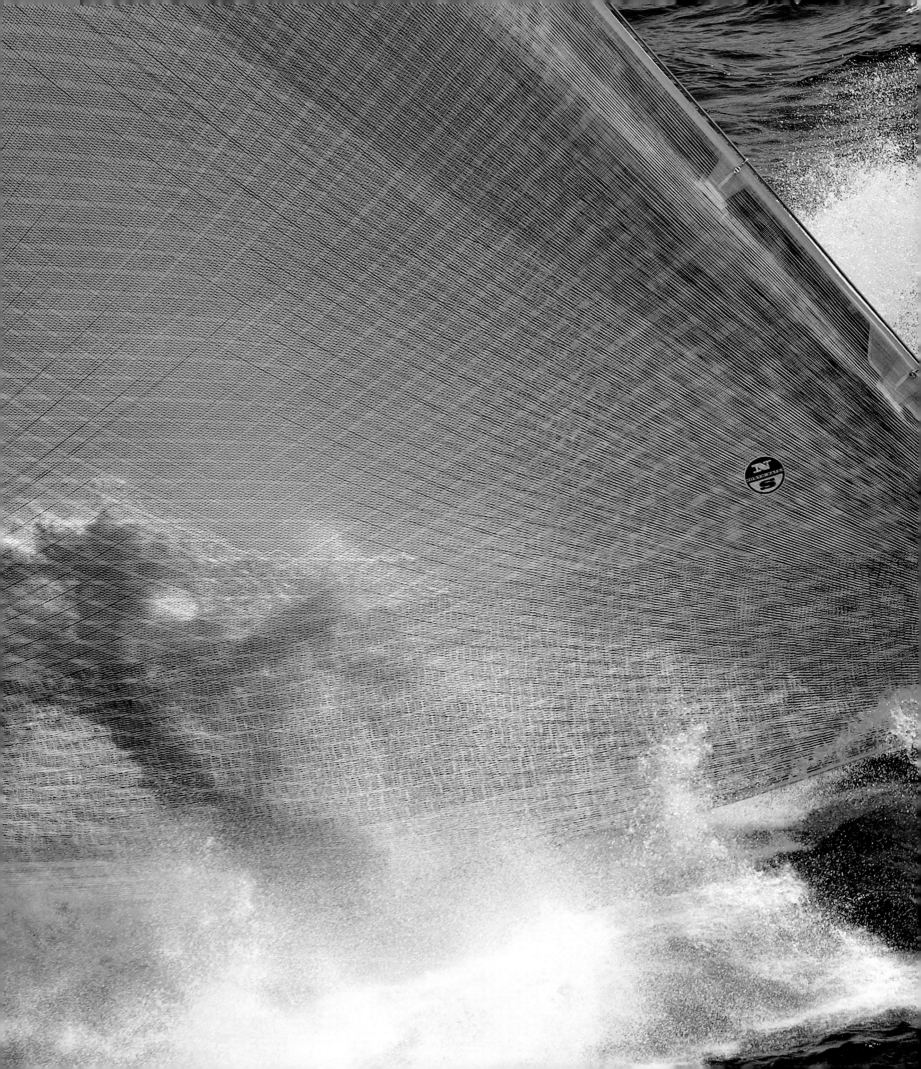

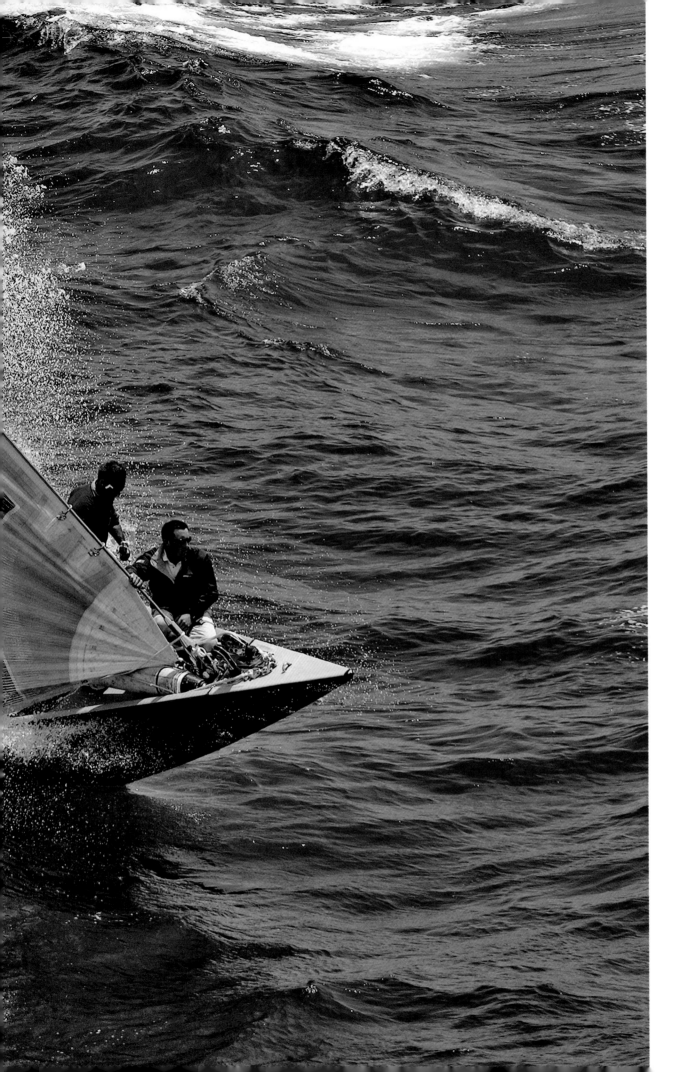

Slender beauty. The long and narrow bow of the English J Class yacht *Velsheda* slices through the waves in the Caribbean.

GPS
THE OCEAN ON SCREEN

Would Alain Gerbault have appreciated GPS when he took to the open sea in 1923 to escape from the ills of modern civilisation? It is doubtful, and one can even speculate that he would have been enraged by a robotic voice from a plastic box telling him to turn right… Nevertheless, this small technological wonder might have spared him many a cold sweat in a few tricky regions and helped him to map out more effective routes.

Marine GPS units are more sophisticated than those found in cars, recognising that skippers tend to see themselves as adventurers and are a bit touchy when it comes to a machine taking over. With the exception of a few rebels, there is now no yacht without a global positioning system, preferably combined with a chart plotter. It is worth mentioning this last detail for the benefit of newcomers unfamiliar with GPS without charts. In the olden days (actually, only 15 years ago), electronic mapping was still in its infancy and the GPS was enclosed in a little black box with just two columns of figures: latitude and longitude, geographical co-ordinates that one had to copy carefully onto the paper chart, trying not to make a mistake with the scale… A useful tool, the GPS then fulfilled a very clear function, namely to verify the boat's position when climatic conditions did not allow for the use of a sextant or when direct visual readings were not possible. This unassuming box did not arrive overnight. It was the late 1970s before anyone had heard of such an onboard positioning system on non-military boats. In those

Paper or electronic charts? Some sailors still hesitate.

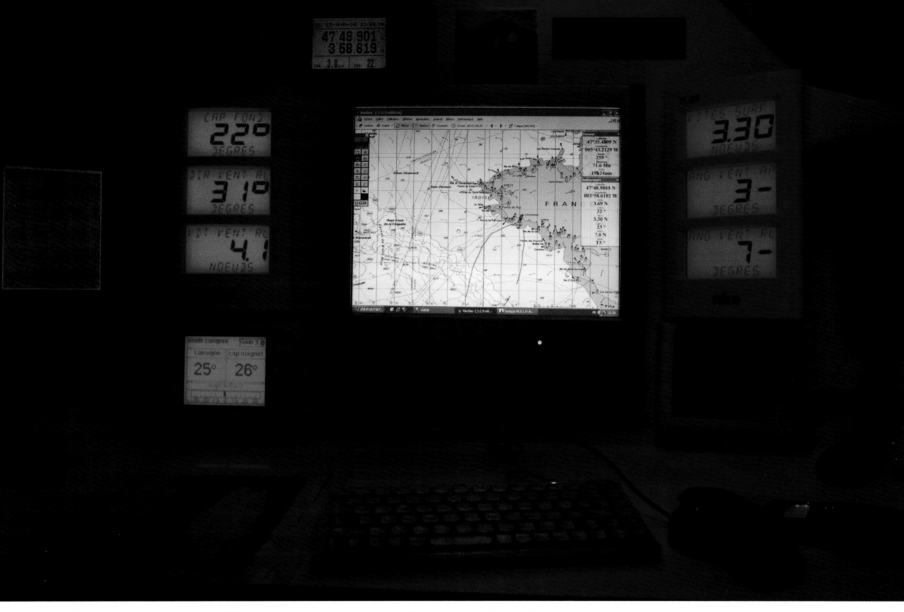

Absolute precision. The combination of GPS and chart plotter has sounded the death knell for more traditional sailing methods.

days each device weighed about 40 kg and cost the equivalent of £50,000.

Today navigation seems more like a computer game where you can follow your boat's trajectory across the screen on a prettily coloured chart, making it almost superfluous to look at the surrounding scenery...Therein lies the problem, of course. These little electronic gadgets are so fascinating that sailors increasingly spend their entire cruise glued to them and forget traditional skills of navigation. The water changing colour, the clouds that cling to an island, the breakers on the shoal, the motion of the swell – these are all small signals that can successfully guide sailors and give them the immense satisfaction that they are perpetuating the knowledge of Cook or Shackleton. So, yes, these small technological wonders are useful, but only if you remember to switch them off sometimes and rediscover the pleasure of getting lost and the excitement of seeing the coastline coming into focus after ploughing uncertainly through the fog!

Navy blue and white
NAUTICAL COLOURS

Can it be the colour of the sea that gives sailors a taste for blue? And what kind of blue? Turquoise as in lagoons? The intense ultramarine blue of the Atlantic islands? The indigo of the deepest Pacific or the azure blue of the Mediterranean? And then there is the thorny question of whether the sea is actually blue. Even if photographers and poets think it is, we now know that this is not true. The sea is actually transparent and if it frequently appears blue, it is essentially because the light that illuminates the water is much less white than it initially appears. The rays of the sun are, in fact, made up of coloured waves that react differently when they come into contact with water. Reds, yellows and greens disappear fairly quickly, whereas blue remains very vivid, even at great depths. This explains why we see it as the only colour. Against a thin backdrop of rain one sees all the colours of the rainbow, in a mass of deep water one only sees the blue. The reflection of the blue sky should be added to this discussion of coloured waves, at least on the days when the sky is truly blue.

So the sea is more transparent than blue, but everyone will agree that a garment with colourless stripes would arouse no great interest. The famous striped top worn by sailors is traditionally navy blue and white, but we don't know for certain what has informed this choice of colours. And why stripes anyway? According to the sociological explanation, sailors of yesteryear considered themselves a class apart and considered it normal to wear clothes that were unlike any others. According to a more technical explanation, the stripes made the sailor more easily visible if he had fallen overboard. This is a plausible argument, but would it not have been easier to wear single-colour outfits, in bright yellow or red, as sailors have come to do nowadays? The striped top was worn under a deep blue jacket, which would have totally concealed the wearer in the water.

Dress code. The elegance of yesteryear's yachtsman, as evidenced by Sir Thomas Lipton.

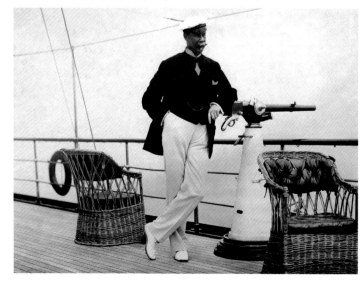

Appearances. The sea is blue, of course, but not always…

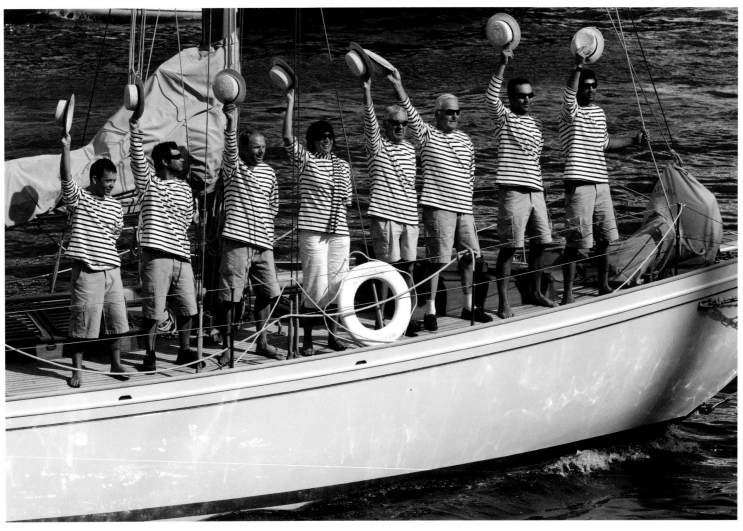

Timeless fashion. The traditional striped top has crossed the generations and still has its place on deck today.

Sailors' tops are striped and not just any old how. A French decree from 1858 stipulates that they should have 21 white stripes, each with a width of 20 mm (a tribute to the number of victories secured by Napoleon) and 20 blue stripes of 10 mm.

Blue and white were the obligatory colours of the navy and were adopted by yachtsmen who – at least in the early days – wanted to look like 'serious sailors', like those in the naval forces. They therefore took to wearing the striped top – with some diffidence, because it was only sailor's garb – but also blue blazers and white trousers. Even if the custom of wearing this outfit has generally been superseded, there are still clubs where it is a must and where suits are considered in poor taste.

Back to basics. After the multi-coloured 1970s and 1980s, the fashion for sailors tends towards single colours again.

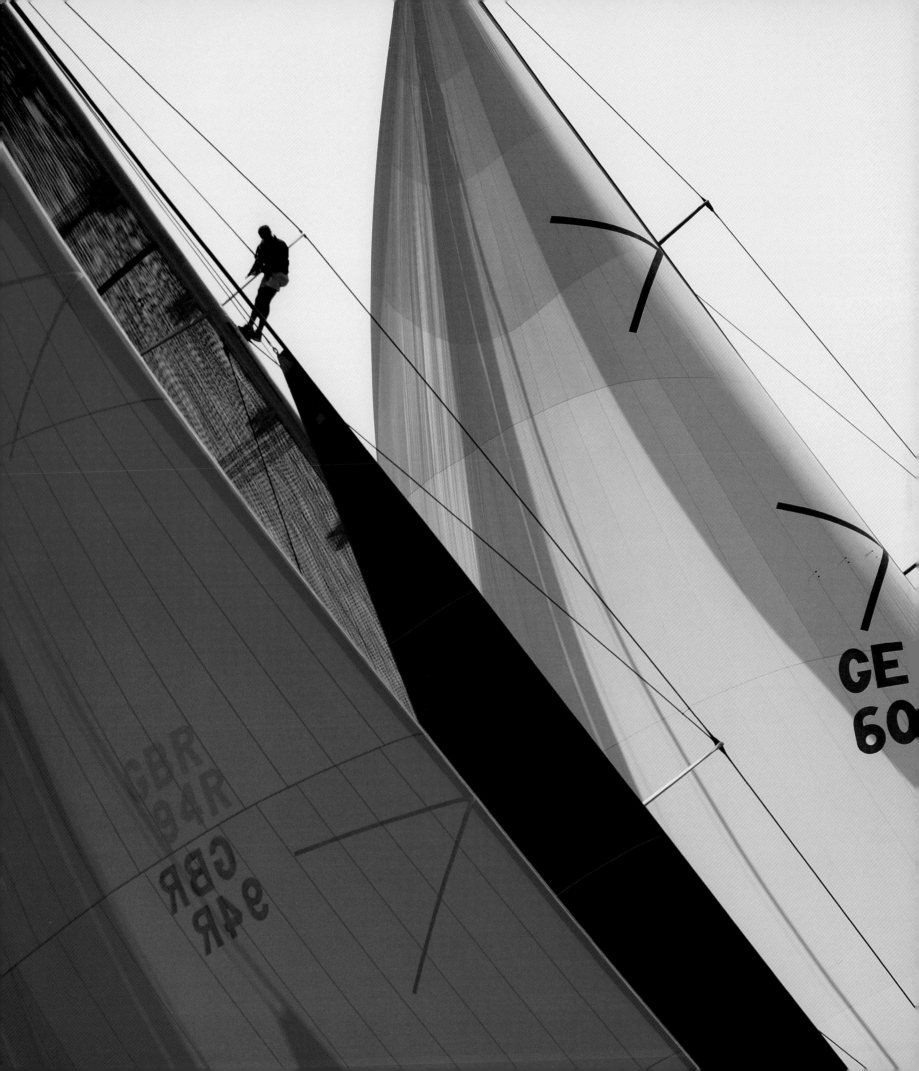

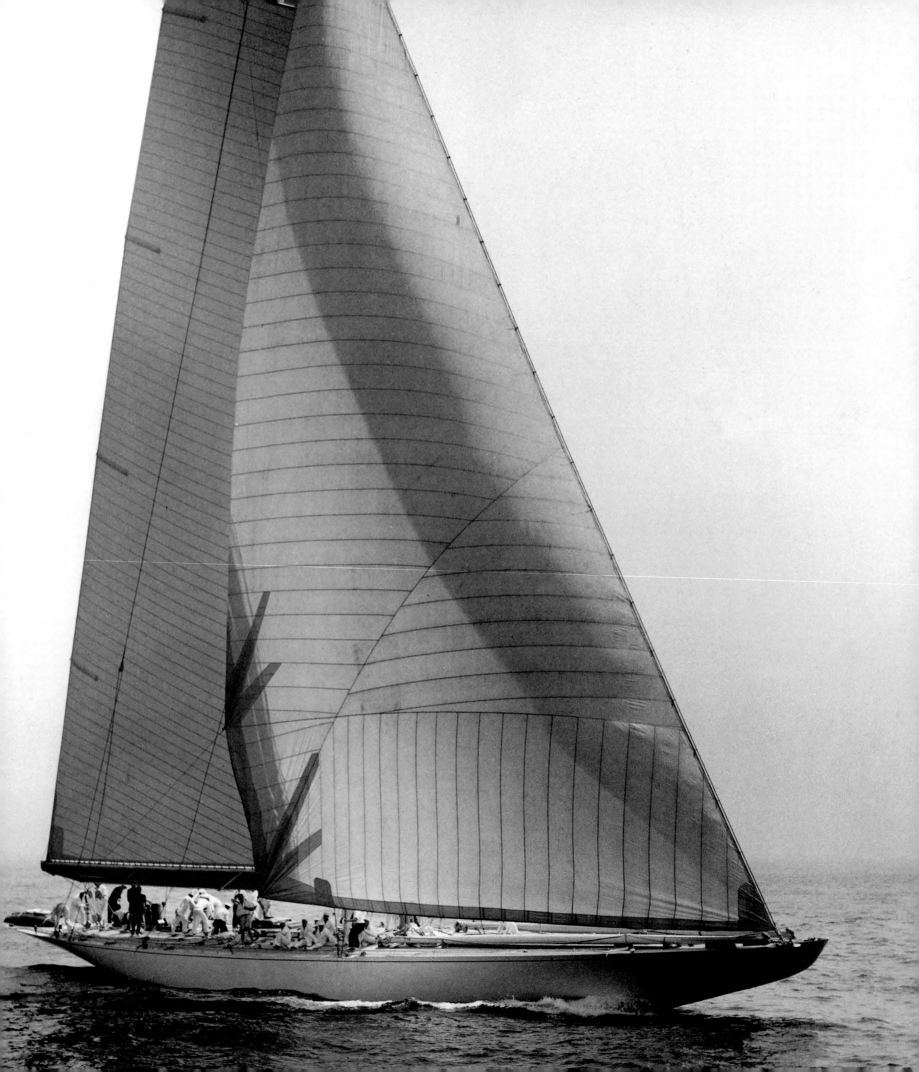

Olin Stephens
THE MAN WHO DESIGNED BOATS

With New York yacht designer Olin Stephens the figures are staggering. He produced 2,600 plans in about 60 years of practice, including eight America's Cup winners as well as an incalculable number of iconic boats signed with the famous S & S (for Sparkman & Stephens). He was responsible for *Finisterre*, which won the Bermuda Race three times in the 1950s and 1960s, and for *Clarion of Wight*, the British hero of the Admiral's Cup in 1963. Not forgetting *Stormy Weather*, as elegant as efficient, which won in 1954, 20 years after her launch. And the legendary 12 m *Intrepid*, star of the 1960s and 1970s at Newport. *Flyer*, which dominated the round-the-world race in 1977–78 and completely revolutionised our approach to ocean racing, was also designed by Stephens.

An entire book would scarcely be enough to enumerate this self-taught man's many successes, which began when he was only 21. Born in 1908, Stephens was more driven by sailing than by his studies and he dropped out of university at the age of 18 to work in the shipyards. Subsequently he became an apprentice to naval architect Philip Rhodes, where he learned all he could while dreaming of one day designing his own boats. In the autumn of 1928, Drake Sparkman – a yacht broker with whom he would subsequently join forces – brought him his first stroke of luck: the commission of a small open yacht (6.30 m) for the Junior Association of Long Island Sound. This was followed in 1929 by the 9 m *Kalmia*, in which Olin and his

Triumph. The young Olin Stephens – top left – on board *Dorade*, the yawl that won everything in 1931.

young brother Rod won the classic New London–Gibson Island race.

Business was sufficiently good for Stephens to rent an office on City Island Avenue and appoint a retired designer to tidy up his plans. Then came *Dorade*, the 16.40 m yawl that would win everything on both sides of the Atlantic in the summer of 1931, skippered by Olin and Rod. Everything was going the young firm's way. Olin designed, while Rod was in charge of managing the boatyards and after-sales service.

Apart from this phenomenal career, several other factors also contributed to the extraordinary popularity of Olin Stephens in the yachting world. Notably the fact that he left behind him a great number of very attractive boats, sufficiently well-built to be still in good shape today; innovative yachts at the time, which have since become classics. The entry into port of *Amazone* or *Stiren* – to select only two among dozens – is an instant conversation stopper. The elegance and gentleness of this unique designer, who passed away in 2008 at the age of 100, have also played their part in the affection in which he is held.

One remembers his 1937 association with a master of the time, William Starling Burgess, which led to the conception of the J Class yacht *Ranger*. A confidentiality clause stipulated that the real author should not be revealed, but observers had no doubt: such a revolutionary boat could only be the work of that young prodigy, Olin Stephens. After Burgess's death, Stephens admitted with characteristic modesty that it was, of course, the old naval architect who had come up with the design for *Ranger*. That's class.

A floating legend. Faithfully restored, the unforgettable *Dorade* still seduces, more than 80 years after she was first launched.

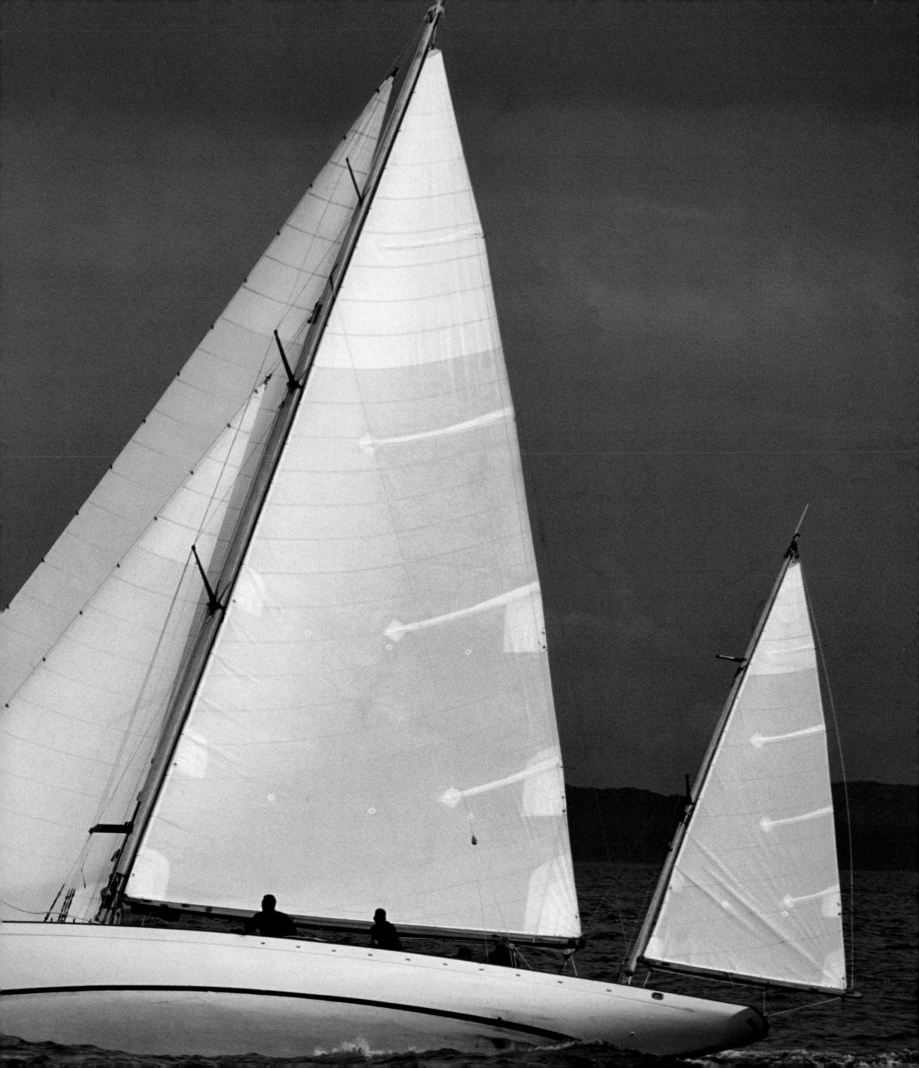

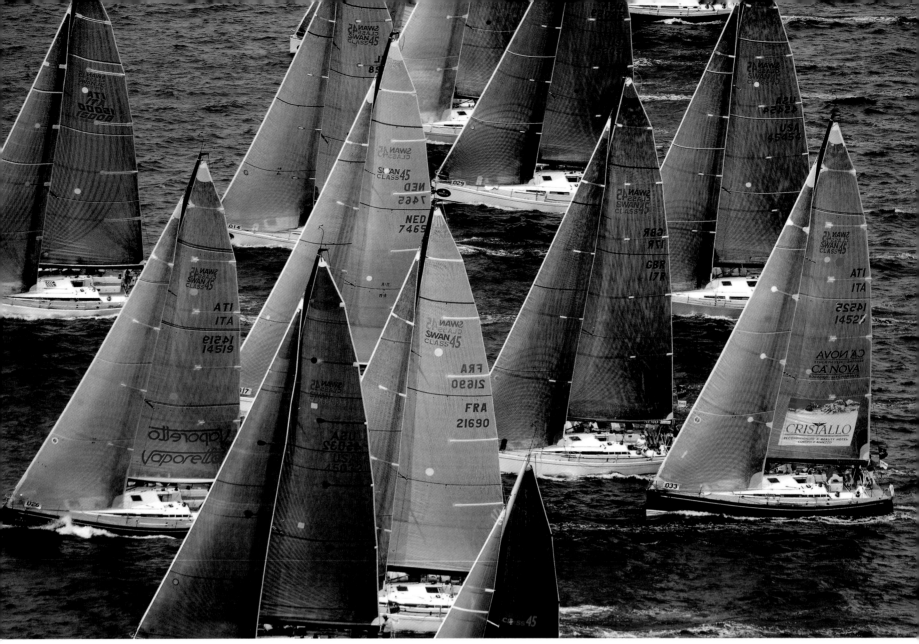

On equal terms. The Finnish yachtbuilder has even brought out a model especially for regatta lovers, the Swan Class 45.

Swan yachts
THE ARISTOCRATS OF THE SEAS

They are more than just simple boats. They have the stamp of quality and are built in 100% good taste. To sail a Swan yacht is to be part of a club where all the members greet one another cordially anywhere in the world, whether they are on board one of the largest boats or the smallest, a vintage one or the latest model. It is not by chance that the make gives rise to a very active owners' club, with highly prized gatherings, regattas reserved just for Swans and many remarkably well-organised social events, both in Europe (north and south) and in the United States. Like a beautiful mansion in a prime location, a Swan yacht is also a serious investment. Don't count on

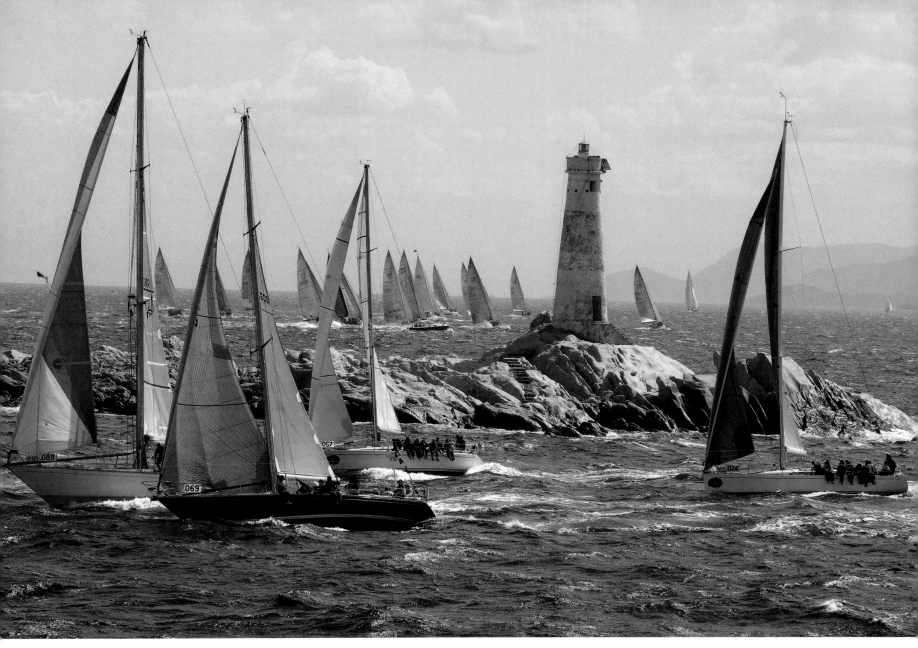

Family spirit. Owners of Swan yachts of all sizes like to meet up every year.

finding an old boat at a knock-down price! No matter how old, a Swan yacht always has a greater sales value than comparable boats.

Has Pekka Koskenkylä, who founded the shipyard where the Swan yachts have been built since 1966, got a secret? His yard, Nautor, has never really distinguished itself for technical innovation or for extraordinary designs. It has simply concentrated on building solid, well-performing boats, which give their owners much satisfaction. The very first Swan yacht, the 36, is a perfect example. For the design, Koskenskylä consulted Olin Stephens without hesitation. Never mind that other people were saying at the time that the

master was in decline. Delivered in 1967 to the Briton Dave Johnson, the first 36 – christened *Casse Tête II* – performed brilliantly in the RORC races, with seven wins out of as many regattas during Cowes Week in 1968. Promoting the model thereafter was easy. The quality of manufacture and the service provided by Nautor did the rest. A total of 90 Swan 36s were delivered by 1970, after which a new version of the boat, the Swan 37, came out.

Meanwhile, a larger model, the 43, was launched, to be followed by others, among which the Swan 65 merits a special mention. Victor of the first Around the World race, the 65 remained in the catalogue for no fewer than 17 years

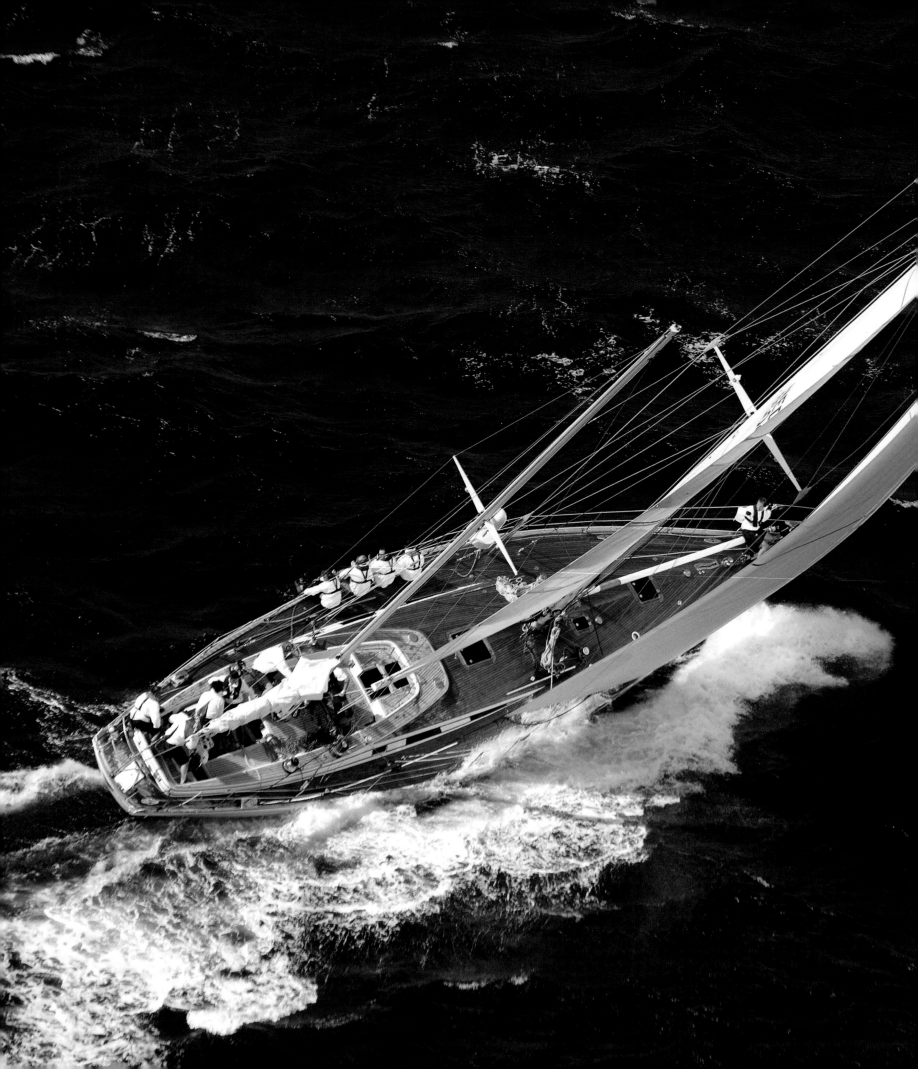

and 41 boats were sold, a remarkable number for a yacht of this size.

In just a little over 40 years, 71 different Swan models were brought out, ranging from 11 m to 40 m. They were designed by just three naval architects, Stephens, Ron Holland and German Frers. This led to the building of more than 2,000 boats in the small town of Jakobstad, in the Gulf of Bothnia, where temperatures regularly drop as low as –30°C. Koskenskylä has given Finland a leading place once more in what was one of the country's mainstays in previous centuries, boat building. Starting out as he did in 1966, he did not have to contend with the delicate transition between wood and plastic. By starting directly in GRP construction, he could, from the beginning, opt for the modern method best suited to boat production.

Luxury and performance.
These two concepts are inseparable in the Swan range, devised for the demanding sailor who appreciates fast, but at the same time comfortable, yachts.

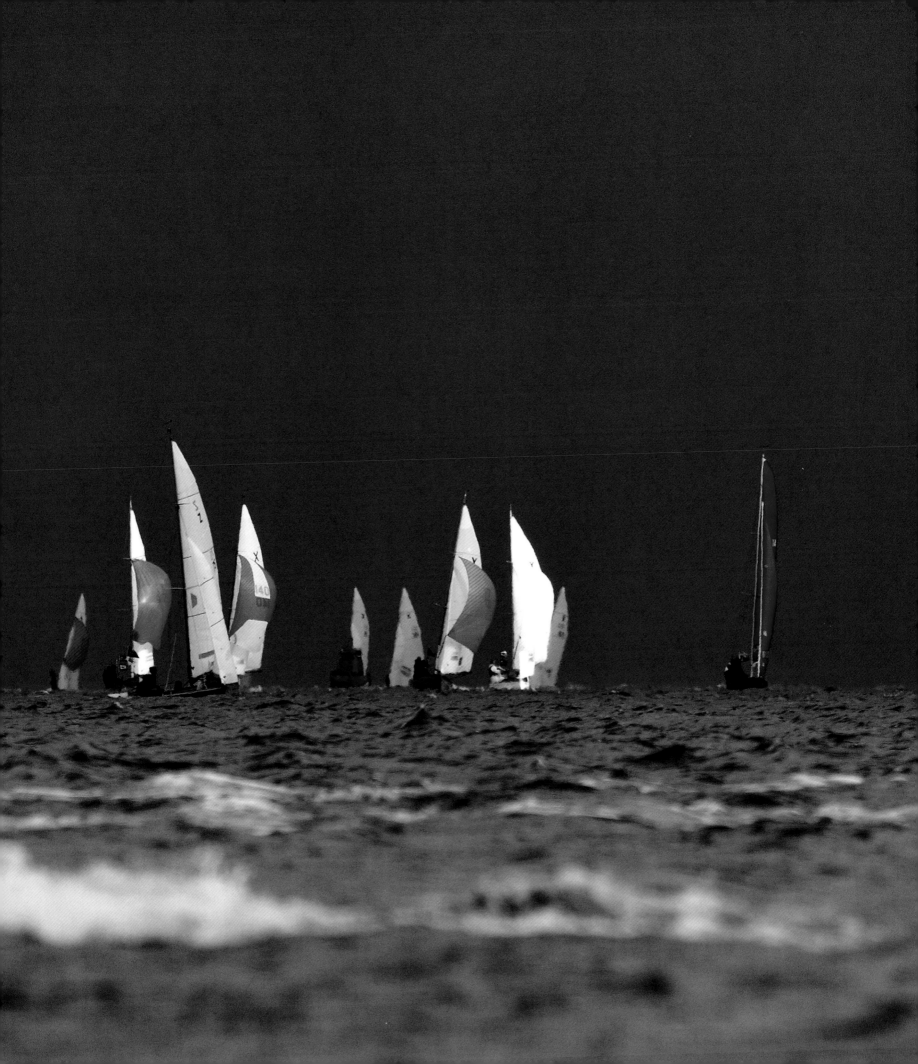

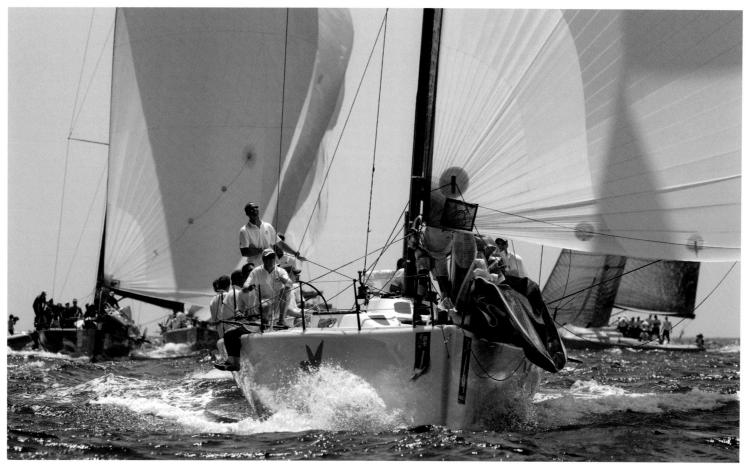

Juan Carlos. The King of Spain frequently takes part in local regattas in his yacht *Bribón*.

Palma, Mallorca
IN ROYAL COMPANY

OPPOSITE

Benediction. Palma's extraordinary cathedral acts as a landmark for yachts approaching the city.

When one thinks of its current image, it may seem paradoxical to associate Palma with the world of yachting. The Balearic Islands in general, and Mallorca specifically, seem more geared to mass tourism than sailing. And the town's prestige is not connected with the history of its local club. The Real Club Nautico de Palma was only established in 1948, virtually yesterday compared with that pioneer of Spanish yachting, the Real Club Mediterraneo, founded in Malaga in 1873. Even the great Barcelona counterparts, the Nautico and the Maritimo, have quite a different historical stature. Nevertheless, Mallorca has slowly but surely established itself as one of the main centres of Spanish yachting, attracting both the international Olympic elite, for the Princesa Sofia trophy at the end of winter, and the most beautiful yachts, which congregate from all over the Mediterranean in springtime for the Palma Vela. This is

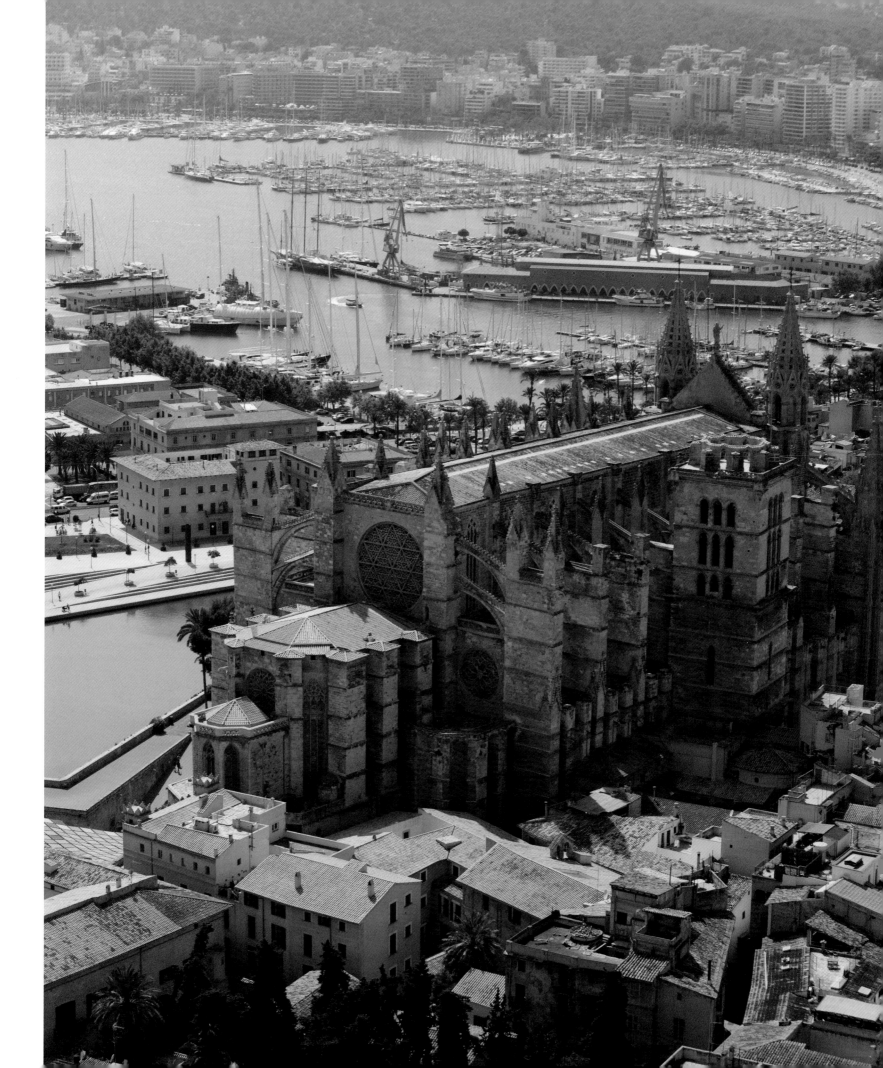

International gathering. Crews of TP52 yachts come from all over the world to take part in this desperate struggle in the vast Bay of Palma.

> ❝ *Which other stretch of water enables you to tack virtually at the foot of a cathedral? One would almost sail there for no other reason!* ❞

one of the few regattas where you can admire in the same view a dozen or so Wally yachts – luxurious and fast boats with a surprising design and impressive measurements. Not to mention the unmissable Copa del Rey, in July, where you could find yourself sailing alongside King Juan Carlos himself.

The competitions are beautiful and popular and, once one has had the chance to sail in the Mallorcan waters, one can easily understand the infatuation. Firstly because the main Balearic island has much more to offer than mass tourism. The Bay of Palma has certainly paid a heavy price for the wave of anarchical concrete typical of the 1960s and 1970s, with its German quarter to the east of the bay and the English and Scandinavian ones to the west. The long and beautiful beaches are packed in summer and it is difficult to absorb ten million visitors each year without consequences… This is all offset, however, by the beauty of the island with its breathtaking scenery and the charm of Palma's historical centre, symbolised by its flamboyant cathedral on the shore, visible from all corners of the bay.

Which other stretch of water enables you to tack virtually at the foot of a cathedral? One would almost sail there for no other reason!

And are we not in the cradle of sea exploration here, where great cartographers lived and worked from the 14th century on? It must also be said that the Real Club Nautico, while not as old as other similar institutions, has much more comfortable trappings. Opulent drawing rooms, superb terraces on the edge of the water, everything permeated by the subtle mixture of etiquette and relaxation that characterises great houses. The Spanish royal family's passion for yachting is no doubt connected with the success of the sport throughout the country and with the particular prestige found in the Real Club Nautico de Palma and other great Spanish clubs.

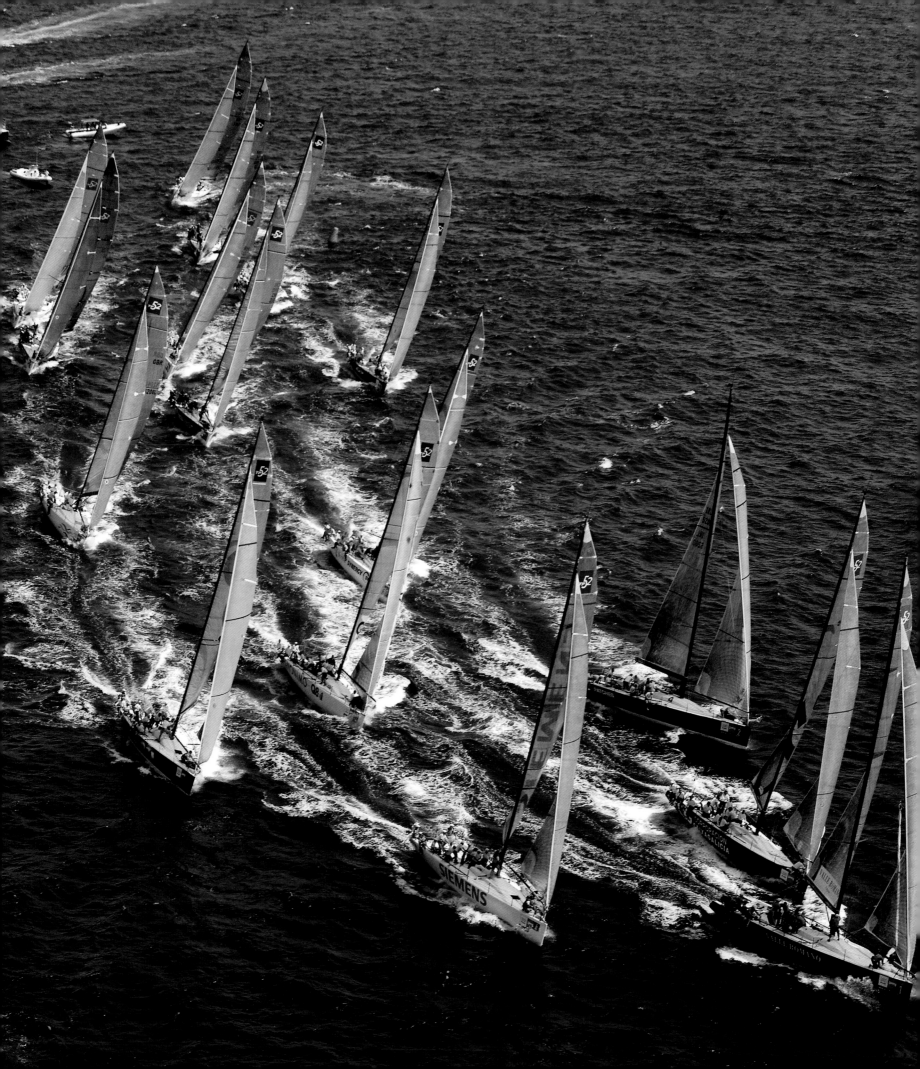

Newport
THE POWER AND THE GLORY

This rather classy town on the Atlantic coast in the small state of Rhode Island is to the United States what Cowes is to Britain. It is, of course, more spectacular and more demonstrative, because we are here in the land of excess. There is no royal family on Narragansett Bay – where 12 America's Cup races were run until the fateful year of 1983 which saw the first American defeat in the race's history – but some regulars in this place are more powerful than royals...

It was in Newport that John Fitzgerald Kennedy and Jacqueline Bouvier were married in September 1953. The Kennedy compound at Hyannis Port is just a few hours away by boat, in the direction of Cape Cod. A great amateur sailor, JFK did not miss a single America's Cup regatta. Just as the British aristocracy, financiers and politicians made the Solent their holiday destination, American men of power took their breaks in Newport from the 19th century on. As with Cowes, the proximity to the centres of power played a determining role as did the development of the railways. From 1833 it was possible to reach Newport by train from New York. The new arrivals added a certain ostentation to the typical New England charm of Newport with incredibly luxurious buildings copied from other continents. Perfect examples of this include Marble House, the residence of the Vanderbilt family, which was inspired by the Petit Trianon at Versailles, and The Breakers, a 70-room mansion in Italianate style, commissioned by another Vanderbilt. Needless to say, all these properties were surrounded by lavish grounds and faced the ocean.

Newport naturally has its own club, but the town's influence in terms of yachting is closely linked with the history of the New York Yacht Club. When John Cox Stevens

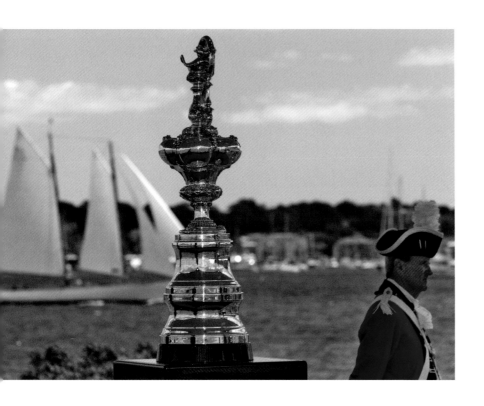

America. Enthusiasts from all over the world spend a fortune to win this silver cup, which only changed hands in 1983 after 132 years of US victories.

Who's who. America's elite meets in the opulent Harbour Court of the New York Yacht Club at Newport.

founded the New York club in July 1844, together with eight friends on board his schooner *Gimcrack*, the first decision he took was to organise an annual cruise to Newport. The first America's Cup races – hosted by Stevens and the New York Yacht Club after the victory of the eponymous schooner – logically took place in New York waters, but the transfer of the race to Newport in 1930 gave the nautical development of the town a big boost. So much so that the prestigious race was at one point inseparable from its port in the eyes of

sailors around the world. Who cared if Newport was not the most appropriate stretch of water for beautiful regattas with its fog and unstable winds…

In the 1960s there was an additional fillip to the myth of Newport. By choosing the port for the arrival of the first single-handed Transat race, Plymouth's Royal Western Yacht Club made it the only place in the world where the opulence of large-budget regattas meets happily with the more informal world of high sea adventurers.

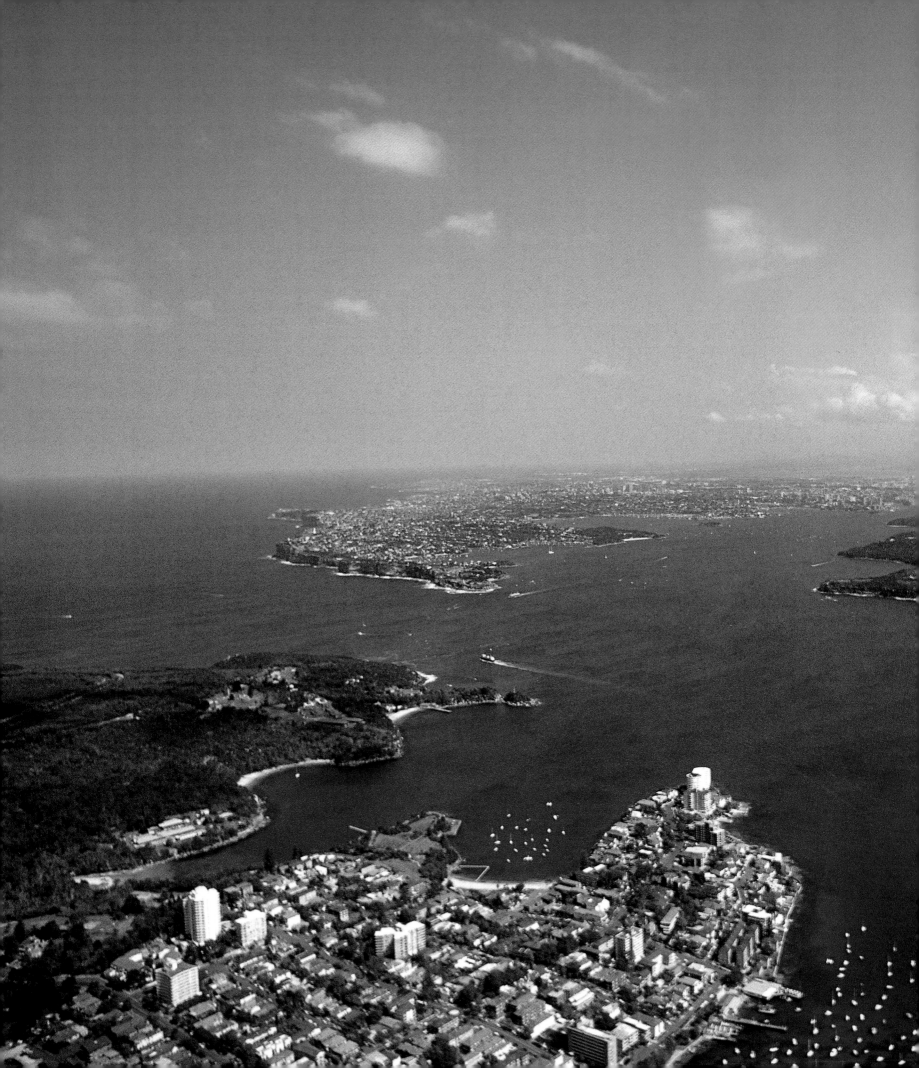

Sydney
A SAILOR'S DREAM

There is a very good reason why Sydney should feature among the iconic places associated with yachting. After all, it is the starting point of one of the world's three mythical ocean races (the Fastnet Race, the Bermuda Race and the Sydney–Hobart Race). Sydney is perpetually linked to the famous Sydney–Hobart Race, 630 nautical miles across the Bass Strait to Tasmania. It is a race that all good Australian sailors dream of and many Europeans and Americans besides.

This race, nowadays reserved only for the strongest of men, was originally just a friendly affair to mark Boxing Day; it was started in December 1945 at the instigation of the Cruising Yacht Club of Australia, which had only been founded a few months earlier. The entire race took a different turn thanks to a British yachtsman who had moved to Sydney at the end of the the Second World War, Captain John H. Illingworth, an active promoter of ocean racing and a distinguished member of the Royal Ocean Racing Club.

Nautical maze. To the left, the Pacific Ocean. In the foreground, the suburb of Manly. In the background, the centre of Sydney, with the countless branches of Sydney Harbour.

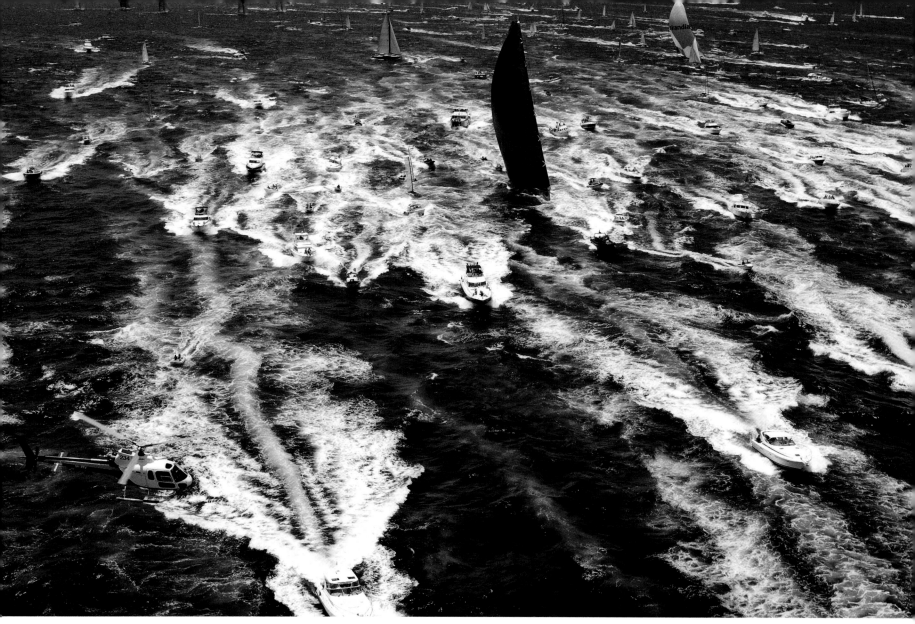

Party time. The departure of the Sydney–Hobart race is always an occasion for festivities on the water.

When the Sydney to Hobart project was first announced, Illingworth bought the 10.70 m yacht *Rani*, became a member of the Cruising Yacht Club of Australia and explained to his new fellow club members that this would be much more amusing if it were a real race... Not satisfied with simply convincing them, he proceeded to win the first Sydney–Hobart race in six days and 14 hours, a day ahead of the runner-up and in much more difficult sailing conditions than the nine competitors had expected. At this latitude the weather changes very rapidly and squalls are often exceptionally violent.

More than 50 years since its inception, the race's wind statistics are impressive. Races where the wind remained at a steady 30 knots are the exception, not the rule. The height of irony is that, having suffered much stormy weather, competitors tend to experience light breezes on the approach to Hobart, which delays the end of the race. This is exactly what happened to *Pen Duick III* and Éric Tabarly in 1967. He was the winner in almost all classes but was becalmed on the Derwent River, very close to Hobart, when a smaller boat, the New Zealand yacht *Rainbow III*, arrived behind him and stole the trophy. Tabarly had to console himself with being the Class I victor.

The reasonable size of the fleet (100-odd boats) and the crews' high level of experience do not, however, prevent damage occurring at high latitudes. In 1998, only 44 crews

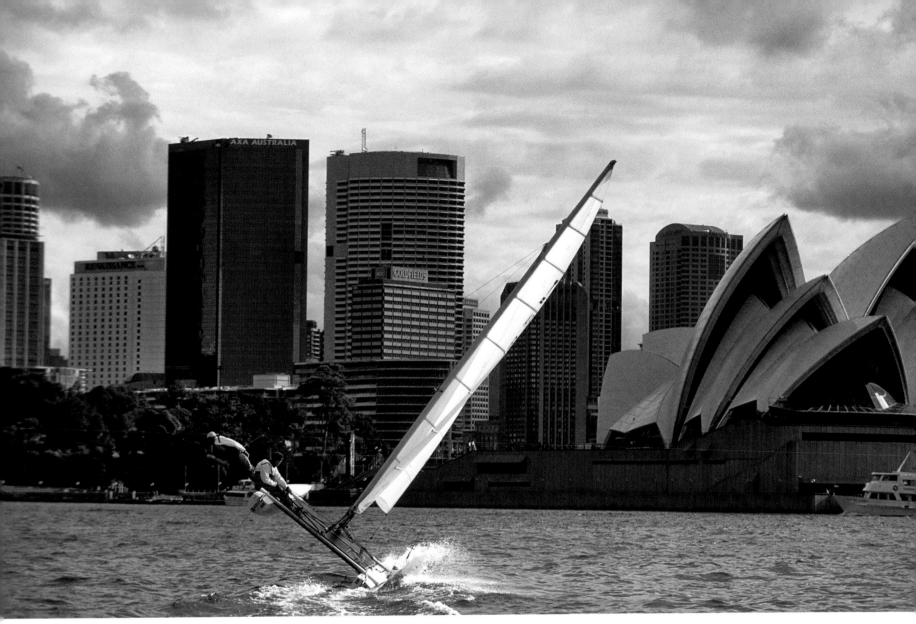

Sailing through town. Here one can travel by boat to the opera or downtown for work.

out of the 115 that started arrived in Hobart, and six crew members lost their lives in a storm. In 2005 exceptional conditions meant that *Wild Oats XI* established a new record of 1 day 18 hours and 40 minutes; in 2012 the same boat won with a time of 1 day 18 hours and 23 minutes. Now maxi yacht owners dream of breaking the 40-hour barrier.

There are other reasons too why Sydney is a dream for sailors. This city, built on a bay crisscrossed by many creeks, has moorings everywhere and very welcoming yacht clubs. It is a city where one can sail into the business district right in the centre of town.

> " At this latitude the weather changes very rapidly and squalls are often exceptionally violent. More than 50 years since its inception, the race's wind statistics are impressive. "

Kiel 1939
REGATTAS ON THE EVE OF WAR

It sometimes happens that smaller stories cross the tragic paths of great history. Just one week before the beginning of the Second World War, yachtsmen from all over the world were in Germany for the Star World Championships. Among them were the Algerians Yves Lorion and Armand Chatord, the only French contestants. The French foreign minister had asked the sportsmen not to go to Germany, but the crew were already en route and their boat was on her way to Kiel at the beginning of August. Because a certain number of

Popular success. A quayside view of one of the last regattas held in Kiel before the Second World War.

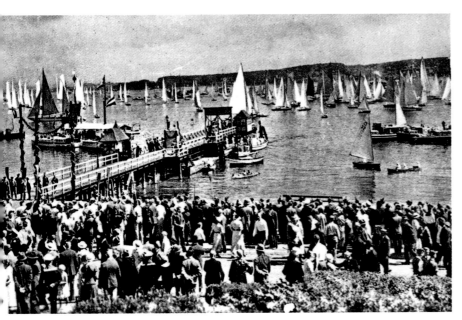

nations had decided not to attend, the championship mainly gathered together Germans, Italians and Scandinavians, with a few American boats. As predicted, the German title holder Walter von Hutschler took the lead in the competition, his dominance only contested by the Italian Augusto Stralino. The German champion, never having hidden his beliefs, made clear his intention to escape the Nazi regime as soon as possible.

He was able to do this after the regattas, travelling through Denmark to Norway with some American crews, the boats transported on horse-drawn carts. Together they were able to board one of the last cargo boats leaving for the United States. On the other side of the Atlantic von Hutschler was welcomed with open arms by the International Star Class Yacht Racing Association, which displayed in a prominent position the world champion's trophy, smuggled out of Germany in von Hutschler's luggage.

Meanwhile, the Algerians Lorion and Chatord had acquitted themselves honourably by finishing in ninth place, but they were anxious about their return home. Fortunately, German naval officers present at the race had the good idea of accompanying them courteously to the border just as the German army entered Poland… Left behind, their Star Class yacht *Aloha* was less fortunate. She was destroyed in a bombardment at the end of the war, as was a large part of the European yachting fleet, which went up in flames or was requisitioned, destroyed or scuttled. Paradoxically, this

> *German naval officers present at the race had the good idea of accompanying them courteously to the border just as the German army entered Poland…*

disappearance of beautiful yachts had one positive effect in the immediate post-war period, when penury led many clubs to turn to more economical boats that would revolutionise the sport.

The passion for yachting never disappeared completely for its followers, even in the middle of a world conflict, and survived in the most surprising places. The Royal Ocean Racing Club, for example, launched a design competition in 1944 to boost morale among prisoners of war. The aim was to come up with a cruiser of around 10 m in length. The contest was only open to soldiers and officers detained in German prisoner of war camps. Drawing materials for the occasion were distributed by the Red Cross.

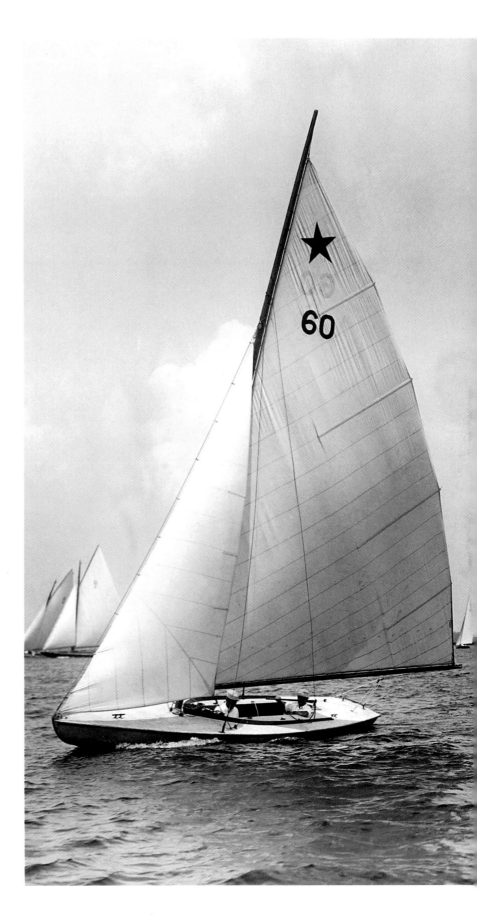

Gone forever. A pre-war Star yacht – a sizeable part of the European fleet disappeared during those dark years.

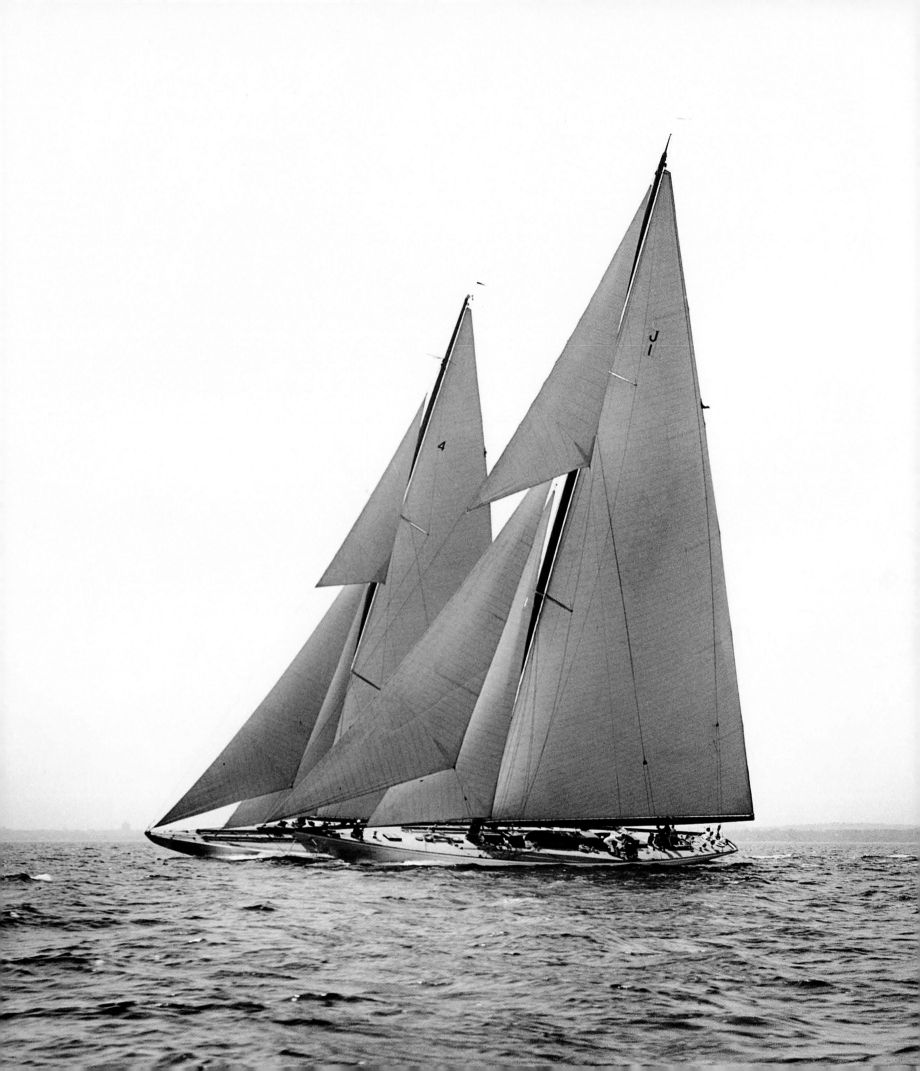

Legal matters
THE AMERICA'S CUP IN COURT

The veritable legal battle between challengers and defenders of the America's Cup paints a disastrous picture of what had until then been yachting's most prestigious competition. This tendency has taken a disturbing turn in recent years, with contestants settling their differences in court and changing the rules to their advantage whenever they get the chance. The Swiss Ernesto Bertarelli is a case in point: he poached a good part of the New Zealand team, who held the title, in order to win in 2003... only to have the 'transfers' barred from participating afterwards. Conflict, however, is no doubt part of the Cup's history given the highly special status of the trophy.

The coveted prize was officially donated on 21 July 1857 by the co-owners of the schooner *America*, who had won it in England six years earlier, so that 'a perpetual contest could be set up to meet all the challenges launched by foreign yachtsmen'. The competitors would have to respect the conditions stipulated in the *Deed of Gift*, which would later become favourite bedside reading for many lawyers. Lawsuit followed lawsuit: after the misadventure of James Ashbury, who had to face 17 American yachts when he was expecting only one, the British yachtsman tried to take the initiative in 1871. In the absence of any clear response, he challenged the New York Yacht Club on behalf of about 12 English clubs, in the hope of being able to race again in his own boat. His request to a challenge was turned down: he would face only one adversary... although this could change depending on the day's weather!

Ten years later, to brush aside the threat of a Toronto challenger set on bringing his boat and all his crew to New York to secure victory, the New York Yacht Club amended the *Deed of Gift*, specifying that only clubs holding regattas on the sea could issue a challenge (so farewell to those lake-based clubs) and that a defeated challenger should have to wait two years before attempting to challenge again.

In 1893 the *Deed of Gift* was amended yet again and was as protectionist as ever. It stipulated that the challenger would be obliged to communicate the detailed characteristics of his boat ten months in advance, whereas the identity of the

> ❝ *Conflict, however, is no doubt part of the Cup's history, given the highly special status of the trophy.* ❞

Cruel beauty. Boats and regattas may be superb (shown here are the J Class yachts *Enterprise* and *Resolute* preparing to defend the America's Cup in 1930), but behind the scenes all dirty tricks are permissible.

Before the battle. The last 'classic' America's Cup race, fought in 2007 (shown here is the eventual Swiss winner, on the left, crossing the path of the South African *Shozholoza*), was followed by three years of legal action.

defender would only be revealed on the first day of the race! The only easing of these rules would occur in 1956 when the 12 m JI was chosen as the official yacht for the race. From then on, no challenger had to join the regatta venue by sea – they could arrive on a cargo ship.

An important detail: because there were no surviving trophy donors, it was the New York Supreme Court that ratified these changes, making this the first legal intervention in this field. It would not be the last. When the New Zealand multi-millionaire Michael Fay wanted to race in a large monohull (41 m) in the spirit of the original *Deed of Gift* and its challenges, he had to fight in court to win the case… and become the fall guy afterwards. The Americans, forced to accept his challenge, picked a fast catamaran as their entry, against which Fay's heavy giant of a boat stood no chance. Fay appealed at various times to prove that such a contest was not equal, but ultimately he had to accept a humiliating and expensive defeat.

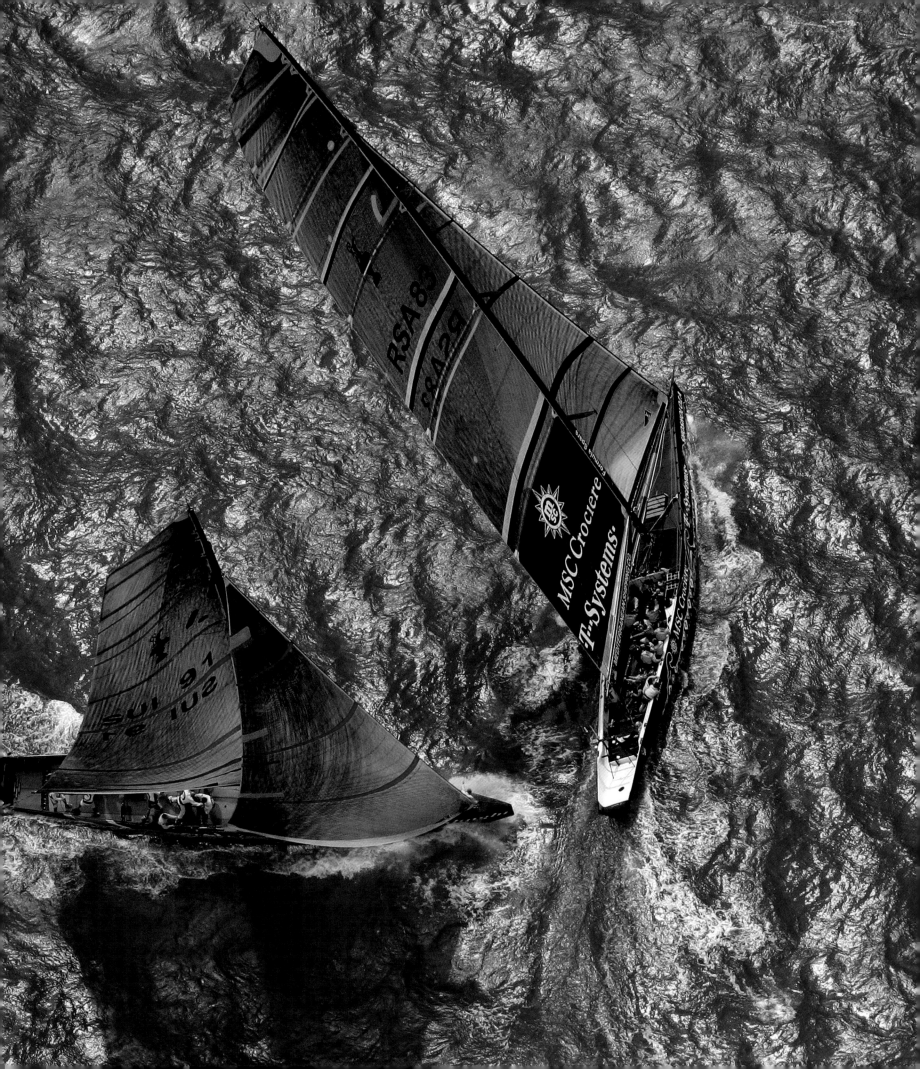

Fashion

OILSKINS, BLAZERS AND STRIPED TOPS

Who would have thought that Helly Hansens, a Norwegian brand more than 100 years old, would acquire iconic status among members of the yachting world and beyond? Its oilskins have become a must-have garment for young city-dwellers with no intention, for the most part, of taking to the open sea. In the 1990s an American rap band, Wu Tang Clan, chose to wear Helly Hansen 'Coastal' jackets on stage for no particular reason, a gimmick that was taken up by other groups in Europe (such as French rappers NTM and Manau). And so this sailing jacket, a serious product conceived principally for use at sea, discovered a whole new market… and multiplied its sales eight-fold almost overnight.

Military outfits: The naval influence is clear in the traditional yachtsman's dress.

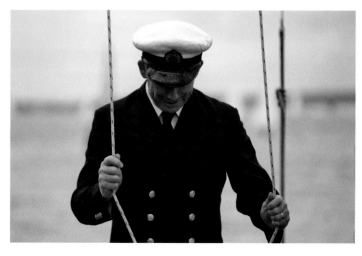

The Norwegian manufacturer eventually began to take this new target market seriously but was cautious not to damage its image with its traditional customers.

Such spectacular and unexpected market shifts are rare, but some of yachting's influence on lifestyle, dress and interior design are undeniable. For example, the over-use of deck shoes and, from the 19th century on, the fashion for straw hats which had its origins in canoeing, an activity highly valued by yachtsmen. In the same way the traditional navy cap won over the general public, before finding itself in competition with the American baseball cap.

Another iconic garment of nautical fashion is the blazer. This double-breasted jacket, traditionally navy blue with gold buttons, was inspired by naval uniforms. Little has changed since the last century, when elegant yachtsmen wore caps and white trousers with it. Since the naval look has become somewhat diluted, this leaves the blazer to be clearly identified with yachting.

A similar phenomenon has occurred with the striped top, scarcely a prestigious garment. Originally worn by fishermen and sailors on warships, it was adopted by yachtsmen who thought there was value in taking up the habits of professional sailors. Subsequently, the striped top passed into modern use thanks to Coco Chanel and Jean-Paul Gaultier. Truth be told, very few garments have been devised exclusively for yachting, but the sport has nevertheless imposed a highly particular style by incorporating various

Rehabilitation. The good old striped top has ended up conquering the hearts of city-dwelling women thanks to Coco Chanel.

Formal dress. Yachtsmen of yesteryear were spared the rigours of foredeck work. Shown here is Sir Thomas Lipton, posing calmly on board his yacht *Erin* in 1900.

elements from elsewhere. The polo shirt, designed in 1933 by René Lacoste, is a case in point. Leaving aside the curious paradox of its name (it was originally devised for tennis players and only later became of interest to polo players), the polo shirt was also appropriated by the yachting crowd to the extent that an individual wearing a polo shirt and linen Bermuda shorts (another garment worn by members of the Royal Navy) would almost immediately be singled out as a yachtsman.

The world of interior decoration is also subject to various subtle naval influences, as can be evidenced by the success of half models of ships, once used as working tools by naval architects and boat builders, and symbols of legitimate pride for yacht owners. And where do you suppose the fashion of having elegant wooden decks on the terraces of our houses comes from if not from teak decks?

Business
CAPTAINS OF INDUSTRY AT THE HELM

If yachting's main figures originally came from among the royalty and aristocracy, the industrial revolution in the 19th century generated a new type of yachtsman who would soon become very influential. The most able entrepreneurs of this period made a great deal of money and were more than happy to spend it (at least partly!) on the water. The most emblematic industrial dynasty to be passionate about boats was that of the Vanderbilts. First there was Cornelius, born in Staten Island, New York, in 1794 into a family of Dutch immigrants. At the age of 11, young Cornelius dropped out of school to be a sailor on his father's ferry. At the age of 16 he borrowed money to acquire his own ferry. Ten years later he was in charge of a shipping company, then of a veritable maritime empire, before launching himself into railroad construction. His descendants, notably his great-grandson Harold Stirling Vanderbilt, would be responsible for launching three consecutive winners of the America's Cup: *Enterprise*, *Rainbow* and *Ranger*, between 1930 and 1937. Harold's adversaries were equally wealthy and had the same entrepreneurial spirit, beginning with the Englishman Sir Thomas Sopwith, owner of the magnificent *Endeavour* yachts, an airplane manufacturer (he created the famous Sopwith Camel, used in the First World War), who liked nothing better than to be at the helm of his own boats in regattas.

Yacht clubs naturally counted among their members a number of financial and business tycoons such as the Rockefellers and the family of Sir Thomas Lipton, the inspired Scottish grocer who has gone down in history both

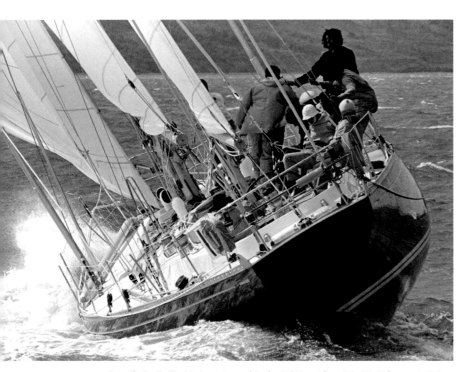

Ramón Carlin. The Mexican winner of the first Whitbread Round the World Race at the helm of the Swan 65 *Sayula II* made his fortune manufacturing washing machines.

Harold Vanderbilt. The New York heir to a transport empire was passionate about the America's Cup.

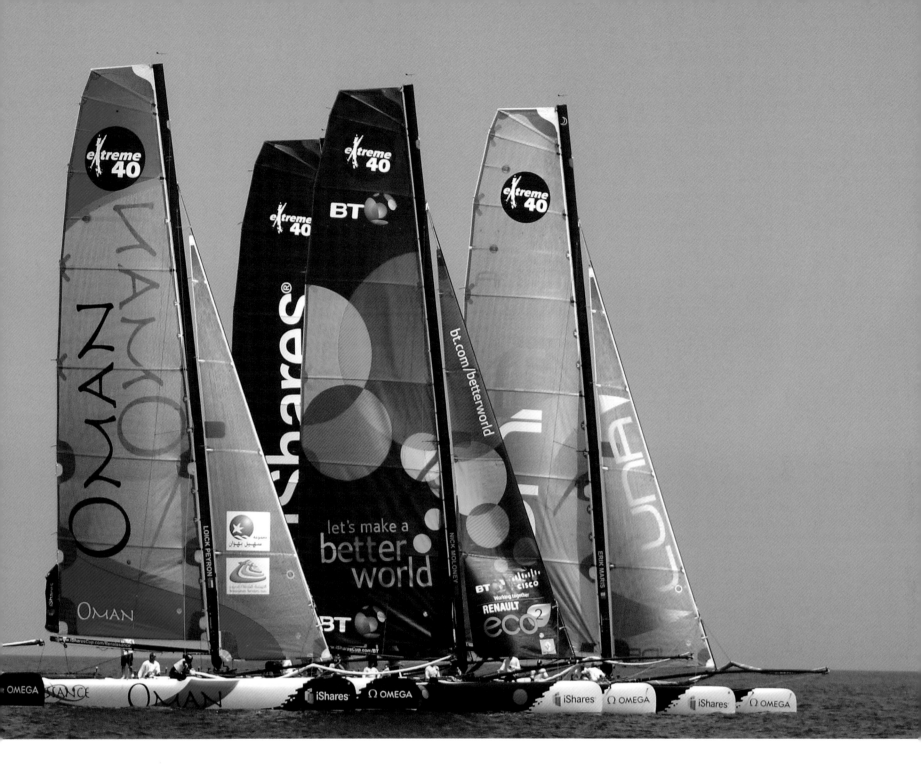

of Claude Lelouch which financed her) to *Vendredi Treize*. Six years later, the launch of the Route du Rhum saw the defeat of those purists who wanted to keep the sea free from advertising. The floodgates soon opened: First there was a name discreetly placed on the stern, then slogans on the topsides and later on the sails. The debate continues to divide sailing buffs. The aggressive use of advertising is often an eyesore, but the sea and the sailing difficulties have not changed.

Films
STARS ON DECK

The definitive film about sailing has yet to be made. Despite being such a photogenic subject, yachting does not have the equivalent of classic surfing movies such as *Point Break* or *Endless Summer*. Nevertheless, boats regularly feature on our screens, but often so clumsily that sailors derive more bitterness than pleasure from their appearance. The rare productions that focus on yacht races are quite simply alarmingly stupid. Take *Wind*, a 1992 film by Caroll Ballard, which grotesquely retraces an episode from the America's Cup, or *The Roaring Forties*, a 1982 film by Christian de Chalonge, an equally misfired evocation of a solo round-the-world race. Both films were created and produced by serious cinema heavy-weights, but still they contain blatant anachronisms and unlikely scenarios that one would never accept elsewhere.

Fortunately, some films that have the sea and yachts as their backdrop have a beautiful atmosphere. Like *Purple Noon* starring Alain Delon at the helm of the attractive sloop *Marge*. British director Anthony Minghella drew inspiration from this film when he made *The Talented Mr Ripley* in 1999, with Matt Damon, Gwyneth Paltrow and Jude Law – a good film but not a patch on *Purple Noon*, which has superior nautical images and better conveys the atmosphere on board a yacht. Phillip Noyce's *Dead Calm* of 1989 (a remake of Orson Welles's *The Deep*), starring Nicole Kidman and Sam Neill, is also worth mentioning: a tense behind-closed-doors drama on a yacht that has picked up a shipwrecked man who is behaving very strangely...

Radically different in style is the French comedy *Liberté-Oléron*, made by Bruno Podalydès in 2001; it takes a fairly realistic look at the small misfortunes that beset ordinary yachtsmen, a world away from the ostentation of the large boats and elegant yacht clubs. Woody Allen's *Cassandra's Dream* of 2007 takes a similar approach, albeit with a more dramatic tone. In it Ewan McGregor and Colin Farrell are so smitten with the notion of yachting that they buy a yacht they do not really have the means to maintain and are thus dragged into a dangerous downward spiral.

The most eloquent scene, however, comes from Fred Zinnemann's unforgettable 1977 film *Julia* in which Vanessa Redgrave and Jane Fonda sail on a small boat. This scene captures the beauty and simplicity of sailing, the sporty nature of this outing in dull weather, the discomfort of the little vessel. All the essence of yachting is concentrated in this short sequence, an enchanted interlude played out against the dark skies of the 1930s.

Jane Fonda and Vanessa Redgrave. A perfect image of 'real' yachting, unsophisticated and damp, during the making of *Julia* in 1977.

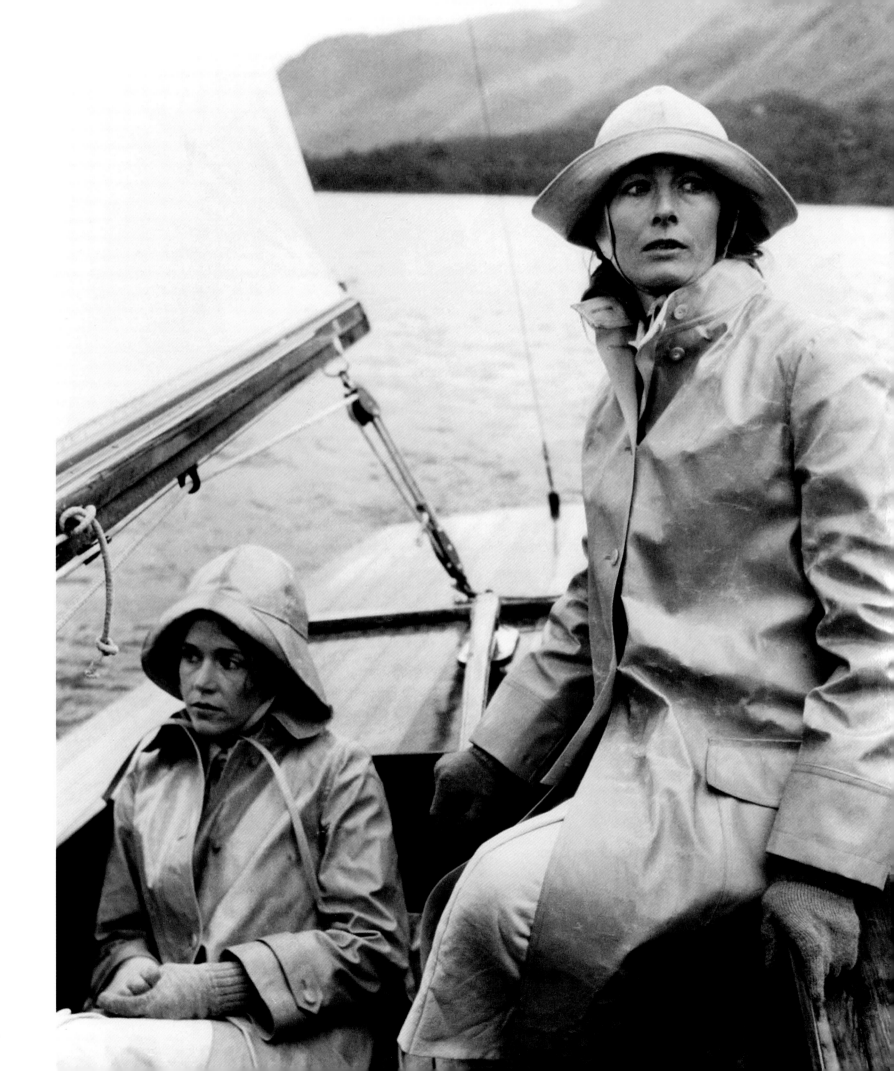

Technology
LABORATORIES ON THE WATER

A strange paradox: Yachting remains one of the few activities that enables us to renew our acquaintance with the rhythms and practices of another age while at the same time regularly proving that we are at the forefront of technology. Sailing is a remarkably slow means of transportation (a medium cruiser often reaches speeds of only 6 mph), restoring all dimensions to the journey, which can triple in time if the wind becomes unfavourable... If you take to the seas with minimalist equipment, you can, if you wish, rediscover gestures and feelings comparable with those experienced by the first explorers of the oceans a few centuries ago. The most astonishing thing is that this extraordinary time machine is at the same time a research centre with unbridled imagination, often producing innovations that can be applied to other fields.

The taste for competition matters a lot here: the vehicle may not be very fast, but that is no reason not to try to improve it. On the contrary, one devotes an excessive amount of energy and resources to this end, often disproportionate to the result, but an infinitesimal gain can be enough to make all the difference. When the celebrated American Class J yacht *Ranger* had the upper hand over her challenger *Endeavour II* in the 1937 America's Cup, the gap between them on the water appeared to be spectacular. If you do the sums, however, the apparent gap is relative. *Endeavour II* progressed at an average of 7.5 knots and *Ranger* at 7.6 knots, a difference of about 2%. This minimal but decisive

The monastic life. To improve their craft's performance, yacht racers have accepted the fact that they need to give up all creature comforts.

bonus was obtained after months of testing the hull and experimenting with different sail cloths and cuts...

Boat builders have always been quick to appropriate finds by military laboratories or aeronautical research centres. From 1946 on, small boatyards started using modern plywood that had been tested by the aviation industry during the Second World War. They also quickly learned to exploit most light alloys and titanium to produce lighter rigging with better performance. From the 1970s onwards, composite materials began to be of interest to the yachting community (while other industrial sectors viewed them with

Exotic. That's what the 'new' fibres (including carbon fibres) are called that have enabled race competitors to make considerable progress.

indifference). The search was on for the best combination of aramid fibres (such as Kevlar) or carbon fibres. The same went for electronics: yachting provided the experimental ground for miniature on-screen cartography, with an integrated GPS. Subsequently, this would be extended to all sorts of users, including car drivers.

Receptive throughout its history to renewable energy, yachting very early on adopted wind generators, hydro generators and solar panels – long before their use became widespread. Forced to live in a small space and seeking maximum autonomy, sailors are used to practising what landlubbers are still reluctant to do: to expend the minimum energy possible and be content with the energy they are capable of producing themselves.

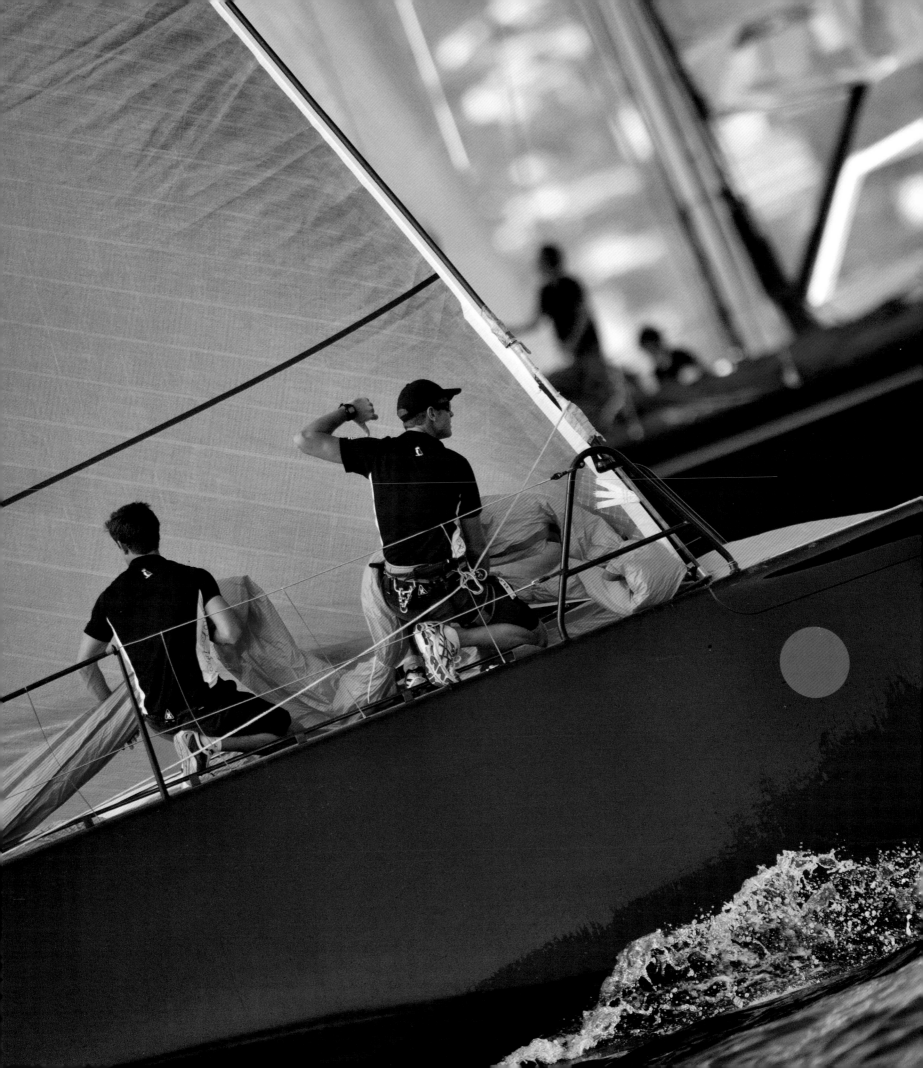

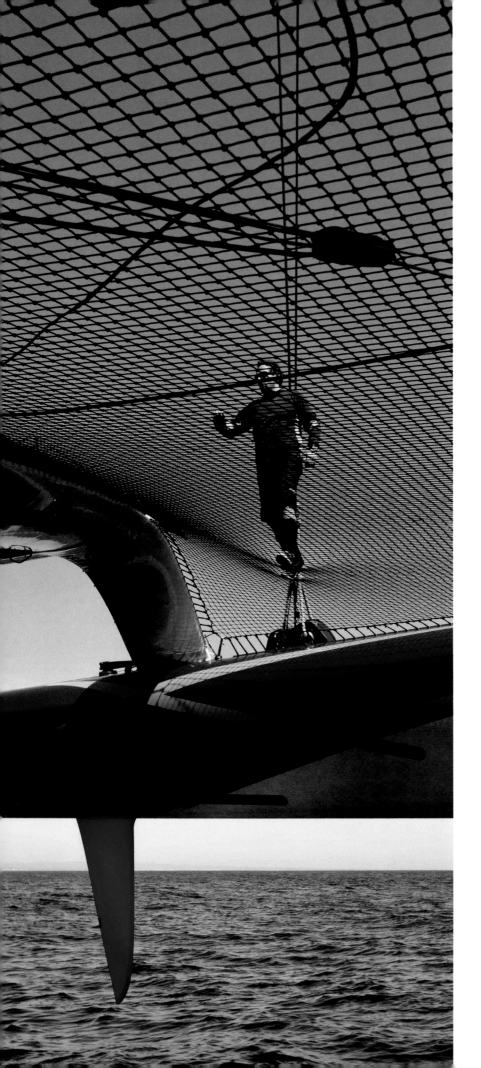

Ocean-going multihulls. The preserve of French sailors who hold all the titles, but then they are almost the only ones to practise this discipline. Shown here is *Banque Populaire V.*

often the same as those attracting more media coverage, with conviviality and fair play thrown in. Rather surprisingly, it was within this group that the Whitbread Round the World Race (which became the Volvo Ocean Race) got started, before it went professional with a monstrously high budget, sponsors and paranoia comparable to the America's Cup.

There is also a lot of money in the quite separate group of the maxi-yachts (that is to say, fast monohulls of at least 25 m length). There are no sponsors here, or very few. The rich owners who equip these elegant boats, which were conceived principally to shine in regattas at San Francisco, Palma, Saint-Barts or Porto Cervo, abhor bad taste. They often find pleasure in taking the helm themselves, assisted by professional crews who wear attractive polo shirts and can hold their own in after-race cocktail parties.

Then there are the single-handers, children of Chichester, Tabarly or Knox-Johnston. A group of British origin, which came into being with the OSTAR and the Golden Globe races, before finding a new home in France, riding on the popularity of the Route du Rhum and the Vendée Globe. Formerly the haunt of bohemians knocking together boats and nowadays controlled by exceptionally gifted sailors surrounded by professional crews, ocean racing has witnessed a divorce between two cultures: single-handed, particularly on multihulls, has become an almost exclusively French speciality, whereas English-speaking sailors remain the masters of 'classic' crew yachting.

We should also mention lake sailing, a speciality so dear to the Swiss, where everyone has the same boat and may the best one win. This type of sailing is present in many countries but rarely with the same series of boat.

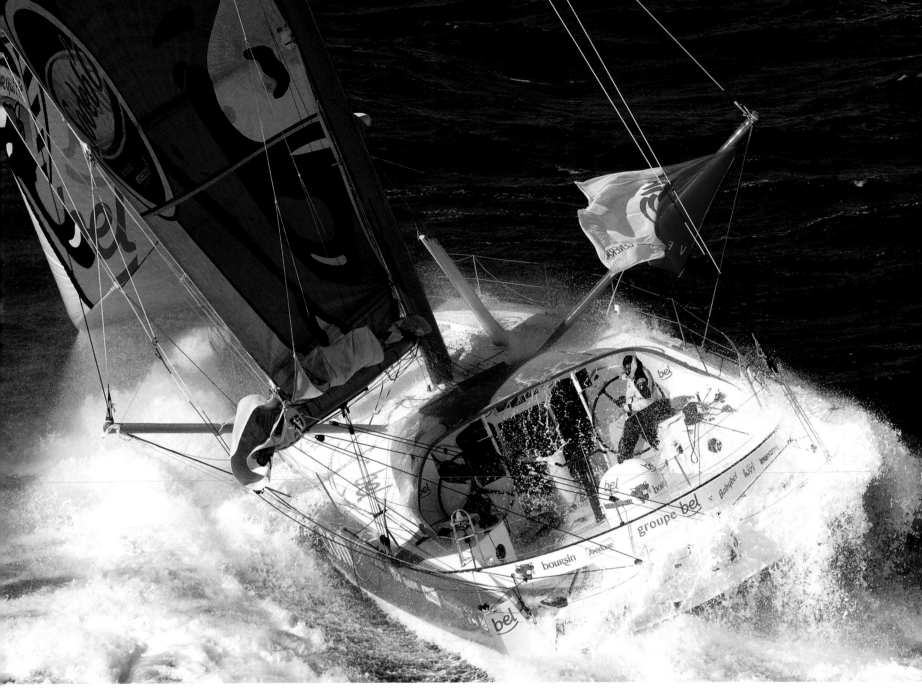

Long-distance single-handers. A French-dominated discipline, brought to the fore in recent years by the popular success of the Vendée Globe.

The only free electrons in this compartmentalised galaxy are the stars of the America's Cup and the Olympic Games who are wooed sufficiently by everyone to be invited onto maxi-yachts or asked to participate in an ambitious ocean race.

Atmosphere
ANTIGUA WEEK VERSUS LES VOILES DE SAINT-TROPEZ

The steady trade winds or the vigorous gusts of the mistral? Tropical relaxation or the traditions of old Europe? 'Both!' reply a good number of crews in unison. They would not miss the autumn outing to Les Voiles de Saint-Tropez or the spring journey to Antigua for anything. These two events enjoy a special status, with a focus on spectacle and party atmosphere as well as high-level competition. Cowes Week may be the most prestigious and the oldest of the great international gatherings (at almost 90 years of age) and the Round the Island race may be much better attended (with almost 2,000 boats at the starting line), but it is the Antigua and Saint-Tropez races that have become unmissable events, each with their own style.

Antigua Week began in 1967, with a dozen crews of charter yachts who wanted to do something different as the season in the Caribbean came to an end. It was nothing to write home about then. By comparison, in the same year, 900 boats took part in Kiel Week and almost 400 in La Rochelle Week. Slowly but surely Antigua gained in fame for a number of good reasons. As the location was strongly marketed and it became more common to charter in the Caribbean, this was an event that suited everyone from customers to professionals. In the early years, local charter yachts made up most of the fleet; then yachts from other Caribbean islands began to converge on Antigua. Following in their footsteps came large American and European boats, with crews excited by the idea of sailing daytime regattas in T-shirts and

spending the evenings under palm trees. Antigua Week has since gone from strength to strength, bringing together a motley fleet of 200 boats at the end of April each year, in the superb twin anchorages of Falmouth Harbour and English Harbour (the one-time base of Admiral Nelson).

The Voiles de Saint-Tropez began in September 1981 with a contest between the owners of the Swan 44 *Pride*

> 66 *Yachts from other Caribbean islands began to converge on Antigua. Following in their footsteps came large American and European boats, with crews excited by the idea of sailing daytime regattas in T-shirts and spending the evenings under palm trees.* 99

Tropical. English Harbour, a favourite of Admiral Nelson's, becomes a hotspot for sailors during Antigua Week.

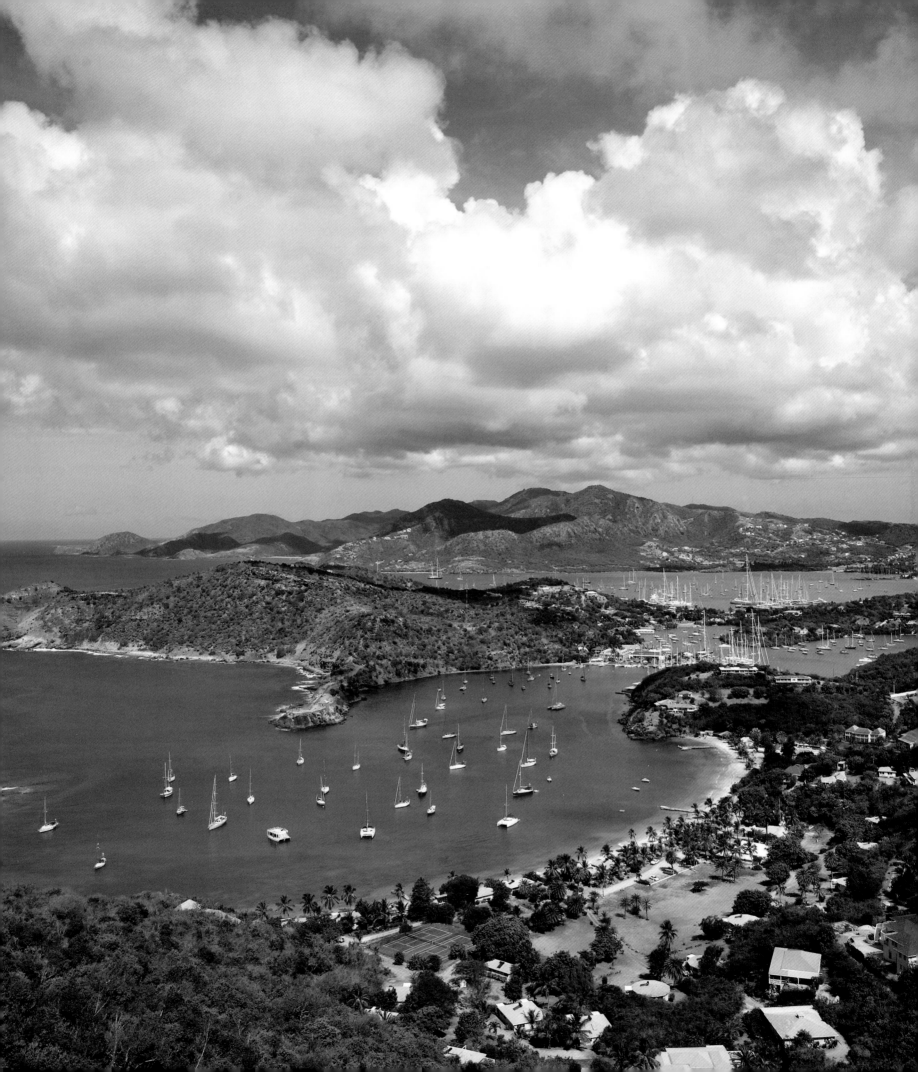

and the 12 m JI *Ikra*. Their aim was to reach the private Pampelonne beach of the Club 55 as quickly as possible. Won by *Ikra*, this race gave rise to the Nioulargue (named after one of the buoys en route), which would become one of the major events in the Mediterranean sailing calendar. After an accident in 1995, the regatta was not held again until its rebirth in 1999 under its present name. From 1999, more than 300 yachts have participated each year. By way of comparison with Antigua, the Voiles de Saint-Tropez certainly has the advantage of attracting an exceptional fleet of classic yachts, 100-year-old schooners and cutters, but not forgetting superb modern boats. No boat that might stick out like sore thumb would be seen here... which is not the case at English Harbour, where any old cruiser can sail alongside sumptuous J Class yachts. The same relaxed attitude can be found on land (with wet T-shirt contests and dinghy races on the beach, for example), while the harbours of Saint-Tropez are the preserve of a small elite.

South of France. In the absence of trade winds, Saint-Tropez can offer an exceptional setting.

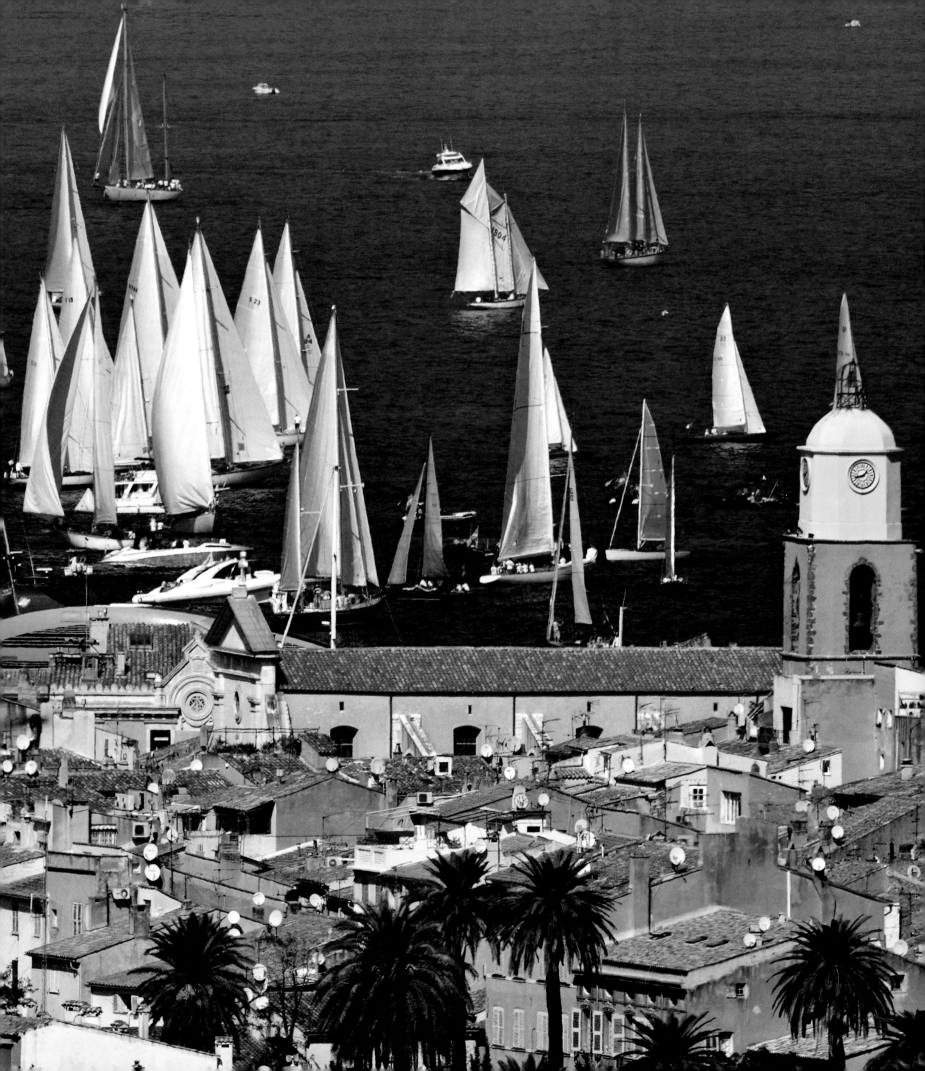

A taste for the ocean
CRUISING ADVENTURES

Joshua Slocum. The first man
to sail around the world single-
handedly poses on board *Spray*
in the shipyard.

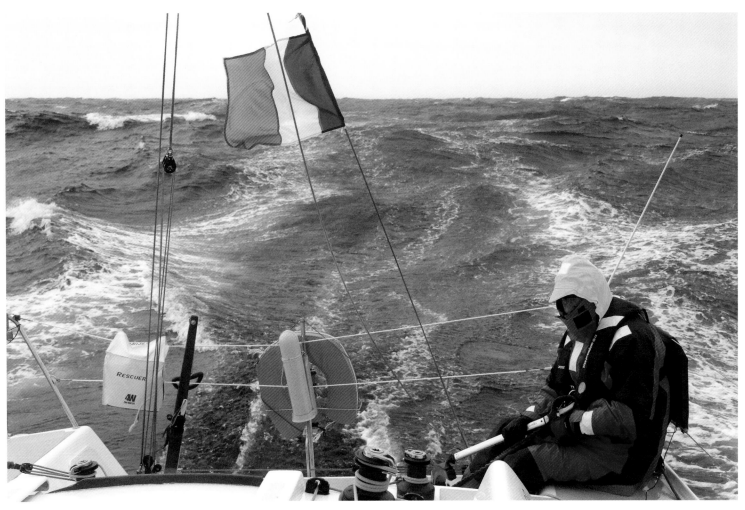

On the high seas. Hundreds of cruising boats cross the North Atlantic every year.

In the early days of yachting, one never lost sight of land or, if one did, it was involuntary. There was no need to sail far away from where your peers could watch you. In those days, you took to the ocean to engage in commerce, to explore the planet, to make war or to seek better fishing grounds, but certainly not for amusement. Mainly a distraction for the wealthy, leisure sailing was thus confined close to shore for a long time, even when regattas became fashionable at the beginning of the 19th century. If racing yachts of the time crossed an ocean, it was not for fun but to take up a challenge on another continent, as with the schooner *America*, which sailed from New York to Cowes in 1851, to compete against British yachts. These were simple deliveries, however, to which boat owners paid no attention, leaving everything in the hands of their professional crews. The first true transatlantic yacht race (as opposed to 'commercial' clipper races, where ships tried to beat each other's journey times coming back from their destinations) was started in 1866 after a bet between three yachtsmen. Only one of them – James Gordon-Bennett Jr – would have enough courage to participate on his boat (the schooner *Henrietta*) in the race between New York and the Isle of Wight. He would not regret his decision. *Henrietta* won the race in just a little under 14 days, thanks to the skill of her captain, Dick Brown, a helmsman on the *America* 15 years earlier. Gordon-Bennett was able to take home a pretty sum in winnings: four times the value of his boat, the equivalent of a few million pounds today. This first great ocean race was curiously held